TALES OF OLD SHANGHAI

A mix of words and images bringing back to life
the glorious past of China's greatest city

Graham Earnshaw

"What does anybody here know
of China? Even those Europeans
who have been in the Empire are
almost as ignorant of it as the rest of
us. Everything is covered by a veil,
through which a glimpse of what is
within may occasionally be caught,
a glimpse just sufficient to set the
imagination at work and more likely
to mislead than to inform."

Thomas Babington Macaulay
British Secretary of State for War
in the House of Commons, April, 1840

EARNSHAW
B O O K S

Tales of Old Shanghai

ISBN-13: 978-988-17621-1-5

Published by Earnshaw Books Ltd. (Hong Kong).

Acknowledgments

The items in this book come from a myriad of sources, and were collected over a number of years. I confess I cannot remember the source of many of them. If any items lack appropriate attribution, or are attributed incorrectly, please let us know, and we will correct for the next edition. We believe all items are out of copyright or are used within the bounds of fair usage.

Thanks to all the people who have taught me something of old Shanghai, shared what they know and what they own. Particularly the late Daisy Kwok. Also Tess Johnston, Lynn Pan, Kent McKeever and Eric Politzer. And especially to Peter Hibbard for his contributions and editing.

Graham Earnshaw

An Old Shanghai Chronology

1842: Treaty of Nanking signed, ending the First Opium War and allowing foreigners to reside and trade at five ports along the China Coast, including Shanghai.

1843, November 17: Shanghai formally opened to foreign trade as a Treaty Port.

1844: The United States and France sign similar treaties giving them similar rights as the British.

1846: First delimitation of Foreign (British) Settlement boundaries, with an area of around 138 acres.

1848: Foreign Settlement boundaries extended to 332 acres. American Episcopal Church Mission set up north of Soochow Creek, marking the beginning of the "American Settlement."

1849: French Concession boundaries defined, with an area of 164 acres.

1851: Beginning of Taiping Rebellion.

1853: "Small Sword" rebels capture the Chinese City and hold it for over a year against an Imperial Chinese siege.

1854, April 4: Battle of Muddy Flat, in which British and American forces attacked Imperial troops to force them away from the Settlement.

1854, July 11: Meeting of foreign residents elects first Municipal Council.

1860, June: The Taiping army captures Soochow (Suzhou).

1860, August 17: First Taiping attack on the Chinese City and Foreign Settlement.

1862, September 21: Frederick Townsend Ward, American commander of the "Ever Victorious Army," is killed fighting the Taipings.

1863: Foreign and American Settlements amalgamated to become International Settlement.

1863, December 4: "Ever Victorious Army," under General Charles "Chinese" Gordon, takes Soochow (Suzhou).

1864, May 1: Establishment of Mixed Chinese-Foreign Court in the International Settlement.

1864, July: Nanking (Nanjing) retaken by Imperialists and Taiping Rebellion crushed.

1874: Riots in the French Concession over a decision to construct a road through the Ningpo Guild cemetery. Shanghai Volunteer Corps called out.

1882, July 26: First public display of electric lighting on The Bund.

1883: Shanghai Waterworks opened.

1889: First modern cotton mill opens in Shanghai.

1897, April 5: Wheelbarrow riots in Shanghai as result of Council's decision to increase wheelbarrow licenses. Shanghai Volunteer Corps called out.

1897, May 10: First foreign (British) cotton mill opened in Shanghai.

1899: International Settlement extended to cover 5,583 acres.

1900: French Concession extended to cover an area of 358 acres.

1902: First two motor cars, Oldsmobiles, arrive in Shanghai

1908: Shanghai-Nanking Railway completed. Tram network officially opened in both the International Settlement and French Concession.

1914: French Concession extended to cover 2,167 acres.

1927: Nationalists, under Chiang Kai-shek, occupy the Chinese city. Thousands of Communists killed and purged from the city.

1928: Foreign parks opened to the Chinese.

1932: First sign of Sino-Japanese hostilities in Shanghai. Japan occupies part of the Chinese city on pretext, but later withdraws most forces.

1937, August 14: Japanese war reaches Shanghai. Bombs are dropped in the International Settlement and Chinese Shanghai is subsequently occupied by the Japanese.

1941, December 8: Japanese occupy foreign settlements.

1943: Foreign powers relinquish extraterritorial "rights."

1945, August 15: Japanese surrender.

1949, May 27: Communist troops occupy Shanghai.

Introduction

There has never been a place like Shanghai – the layers and depth of richness that the city possesses is extraordinary. This book attempts to give a feel for the world of Old Shanghai through a collage of words and images.

It is not a history book in the usual sense of the term. There is no need to start at page one and read through to the end. It is a jumble of items which evoke the different eras of Old Shanghai.

Old Shanghai as it is usually known lasted for just over 100 years, from 1843 when the British set up the first foreign settlement to 1949 when the Communist troops marched into the city. There were many Old Shanghais, each of them special in time and place, filled with paradoxes and clashing contrasts. Shanghai was run by foreigners but was not a colony. Most residents were Chinese but it was not ruled by China. It was the greatest city of Asia in the first half of the 20th century, completely eclipsing Hong Kong and Tokyo. It was one of the most cosmopolitan places that ever existed, full of growth and speculation, of rogues and adventurers, of color and life. And of poverty and death.

Old Shanghai was the worst and

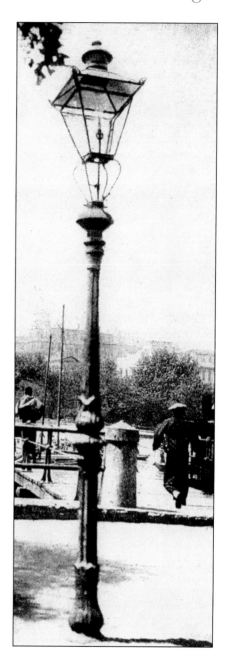

the best of everything. It was the "Whore of Asia" and also the "Paris of the East". It was a "paradise for adventurers", and many other cliches, some of them true. Over the decades, it was a haven to millions of people, both Chinese and non-Chinese, who sought refuge there from war and poverty.

The city had such a bad reputation in certain quarters that it gave rise to the verb "to be Shanghai-ed", which meant to be drugged and shipped off to sea as a sailor, a reflection of the problem ships' captains often had when they arrived in Shanghai in putting together enough of a crew to set sail again. Or else a reflection of the reputation for mystery that the city enjoyed.

Shanghai (v.t.)
Nautical slang. To kidnap a sailor while unconscious from drugs etc; to trick into an awkward situation.

It was by far the biggest city in China, with a population that by 1927 had topped two and a half million. It was the most industrialised city in China, and it was a significant centre of intellectual activity. For bourgeois thinkers, its middle class pointed the way to the future for China, while to more revolutionary thinkers, its vast ranks of industrial workers carried the promise of revolution. Western visitors to Shanghai reported a "treaty port mentality" amongst foreigners here, while Chinese residents were prone to "Yangjingbang culture," a term describing the foreign-influenced habits, dress and speech of many of Shanghai's Chinese residents.

(Yangjingbang was the name of the stream which separated the International and French Concessions until it was filled in and became Avenue Edward VII and later Yan'an Lu.)

There were several Shanghais, and there was surprisingly little overlap between the different worlds. Western visitors saw a western city and foreigners living in the city had little need of contact with the Chinese around them. Very few learned to speak even basic Chinese. The world of the "Shanghailanders" was based on the classic British colonial model — there was the racecourse and the Club, and a church. There were the trading houses and the banks. There was the arrogance of racial and

cultural superiority, although not as bad as in, say, Hong Kong.

The Chinese in Old Shanghai also lived in their own world, denied many of the privileges of the foreigners but nevertheless thriving in the foreign-controlled enclave.

The ambiguities of Shanghai's situation, the legal basis on which it was founded and the support it could rely on, all started to come to a head in the 1920s. China was

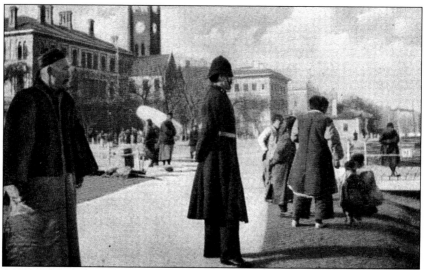

A postcard from the early 1900s. British Bobby on the Bund.

experiencing internal upheaval as revolutionary forces gained strength while central authority crumbled. Japan was flexing its muscles. The certainties of the old world disappeared and the home governments were often ambivalent about their support for Shanghai.

Shanghai was above all a young city. It had all the disregard and even contempt for tradition that new cities and societies have, and a desire to be up-to-date and fashionable in all things.

It pointed the way to the future of China, but paid the price for being premature.

This book doesn't attempt to be comprehensive. It is a dragonfly dancing across the surface of Shanghai's history, touching on a few interesting bits, stressing the Shanghai of the foreigners and leaving out all sorts of great stuff. It was inevitable. A book only has so many pages.

Muen Church at 316 Tibet Middle Road

To Make Money

"In two or three years at farthest I hope to realize a fortune and get away. And what can it matter to me if all Shanghai disappear afterwards in fire or flood? You must not expect men in my position to condemn themselves to prolonged exile in an unhealthy climate for the benefit of posterity. We are money-making, practical men. Our business is to make money, as much and as fast as we can — and for this end all modes or means are good which the law permits."

A trader writing to the British consul, 19th century

9

Postal Traffic

An excerpt from an article published in The North China Herald *on June 21, 1924 commenting on the opening of a new and spacious post office.*

The fine new premises built for the Chinese postal authorities to replace the building in Szechuen Road as Shanghai's district head post office are nearing completion, and, by September it is confidently expected will be complete. The congestion in the present post office should be completely eliminated, for the new premises are large and commodious enough to take even Shanghai's postal traffic, — if the term is permissible. Certainly the counter space is larger, the counter in the parcels department being 523 ft. in length, and that in the public hall, 515 ft. Some idea of what this means can be gathered by picturing H.M.S. Hawkins, and chopping off a little under one-sixth of her length; then take what remains and you have the size of each of these counters. The Shanghai Club bar will be no where in it.

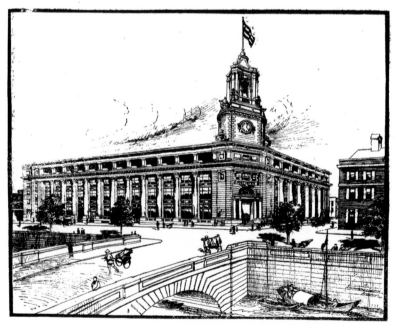

ǀ IMPOSING VIEW OF THE NEW POST OFFICE AS IT WILL APPEAR FROM NORTH SZECHUEN ROAD BRIDGE, SHOWING THE TWO MAIN COLONNADES. THE CLOCK TOWER IS 200 FEET HIGH.

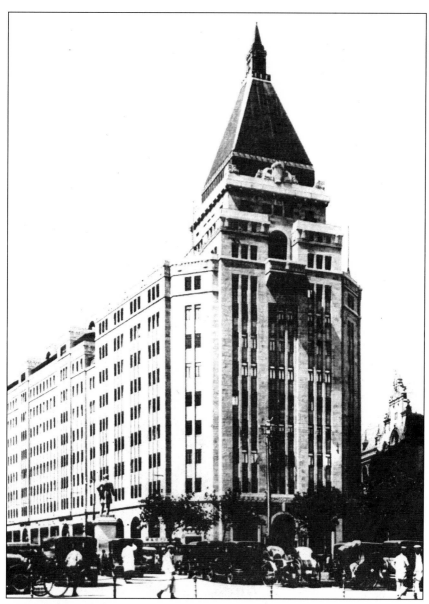

Sassoon House, on the corner of the Bund and Nanking Rd. Now the Peace Hotel. This photo from the early 1930s.

All About Shanghai

The opening words of a famous travel guide on the city, published in 1934

Shanghai, sixth city of the World! Shanghai, the Paris of the East! Shanghai, the New York of the West!

Shanghai, the most cosmopolitan city in the world, the fishing village on a mudflat which almost literally overnight became a great metropolis. Inevitable meeting place of world travellers, the habitat of people of forty-eight different nationalities, of the Orient yet Occidental, the city of glamorous night life and throbbing with activity, Shanghai offers the full composite allurement of the Far East.

Not a wilderness of temples and chop-sticks, of jade and pyjamas, Shanghai in reality is an immense and modern city of well-paved streets, skyscrapers, luxurious hotels and clubs, trams, buses and motors, and much electricity.

Less than a century ago Shanghai was little more than an anchorage for junks, with a few villages scattered along the low, muddy banks of the river. What it will be a hundred years from now is a test for the imagination. Principal gateway to China, serving a hinterland population of more than 200,000,000, many close observers believe it will become the largest city in the world.

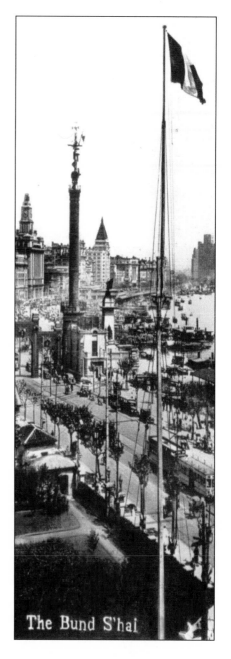

The Bund S'hai

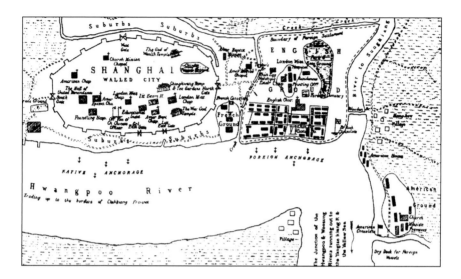

The Megalopolis of Continental Asia

Fortune magazine's article on Shanghai in January 1935 began thus:

The Shanghai Boom ... began with the self-styled younger brother of Christ and might have trebled your money from '27 to '34. Here, the tallest buildings outside the American continent; the biggest hoard of silver in the world; Russian girls; and the cradle of new China.

A city is dedicated land. The dedication may be to government, to trade, to manufacture, to shipping, to finance. But Shanghai's land, likewise dedicated, is dedicated to none of these. Shanghai, the fifth city of the earth, the megalopolis of continental Asia, inheritor of ancient Bagdad, of pre-War Constantinople, of nineteenth-century London, of twentieth-century Manhatten — where the world's empires coinhabit twelve square miles of muddy land at the mouth of a yellow river — is unique among the cities. Shanghai's land is dedicated to safety.

How to Pronounce "Bund"

This is the most mis-pronounced word of all. It is not pronounced in a Germanic way. The word has Sanskrit origins, and the Shanghailanders pronounced it to rhyme with "shunned".

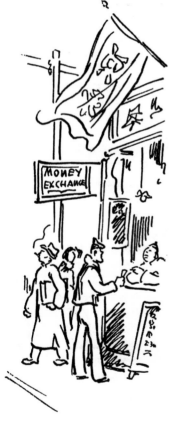

Headlines from May, 1949

and DAILY SKETCH

REDS IN SUBURBS OF SHANGHAI see page 2

FIGHTING IN SHANGHAI SUBURBS

U.S. ending air link

Sink of Iniquity — an expression used of Shanghai by the Duke of Somerset in Parliament in 1869. It is not generally known that the accusation was against the commercial morality of the place. The Duke's authorities were naval officers. The Chamber of Commerce considered the question of officially noticing the bad language used, but wisely let the matter drop.

An item from the Encyclopaedia Sinica, written by an English missionary named Samual Couling and published in 1917

14

High Lights, Low Lights, Tael Lights

Excerpts from the introduction to a book written by Maurine Karns and Pat Patterson in the mid-1930s, revealing the seamier side of life in Shanghai

PEOPLE have a good time in Shanghai, often because they have more time in which to enjoy themselves than they would have elsewhere, more often because the number of friends that people have coming through, or staying for a short time gets them into the habit of entertaining and being entertained, but most of all because it is apparently a part of the Shanghai psychology to have as good a time as possible as often as possible. Even the missionaries get around, we understand.

Principle among the methods of diversion seems to be the good old pastime of stepping out. This is done by getting into the glad rags, taking on a few quick ones, going to your favorite evening spot, then somewhere else, and so on, and so on, until you wind up at either Del Monte's or the Venus. Then home. Bed, milk of magnesia, and late to the office.

Newcomers to Shanghai, upon seeing the magnificent Race Course often got the idea that this forms one of the town's more exciting

diversions. Unfortunately, this is not true. Racing in Shanghai is, in the words of our houseboy, no use. The system of betting is, in the first place, all wrong according to the standards of people who enjoy betting horses elsewhere. In the second place, there are no horses in Shanghai – at least, not race horses. There are a number of animals who might possibly get by in the pony class at a Children's Gymkhana elsewhere, but no horses to inspire a bet five on the nose to win. The horse business, in Shanghai, is in the hands of gentlemen riders, most of whom are at least gentlemen. Some of them ride very well, indeed. A race meet however has the atmosphere of an English fox hunt, and nobody much is interested in an English fox hunt except the hunter and the fox.

Hai Alai, which takes place continuously out in a splendid new auditorium in Frenchtown is interesting, has many followers and is as good a way to lose your shirt as we know of. You can lay a bet

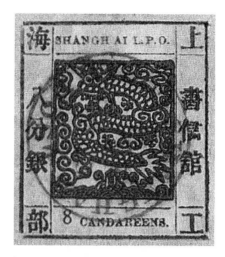

here just as easily as you could get converted at the Methodist Mission. Hai Alai is an old Basque game, and tho town is filled with Basquards who have been imported to lend the local game an authentic touch.

Dog racing occurs regularly at the Canidrome, also in Frenchtown. Whippets chase each other around the track after a phoney rabbit and a good time is had by all. Betting is on the pari-mutuel system, the club getting fifteen per cent of the take. Betting tickets are bought in two dollar and five dollar denominations. This is as wacky a way to lose your money as we know of.

For those who like to gamble, the State Lottery offers a slower if no surer means to the big money. A ticket costs ten dollars, a share (one tenth part of a ticket) sets you back a dollar. The big prize is 250,000 dollars but there is a complicated system of less important prizes and

MUNICIPAL COUNCIL.

SHANGHAI.

STANDING ORDERS OF THE COUNCIL, AND SUB-COMMITTEES.

ALSO

GENERAL INSTRUCTIONS TO, AND DUTIES OF, OFFICERS OF THE COUNCIL,

AS FRAMED BY THE COUNCIL OF 1865, AND AMENDED BY THAT OF 1868.

one's impression upon reading the list of awards is that everyone in China should receive some kind of prize. We have never known anyone who won a pretzel in this lottery, however ...

No small part of the nocturnal street scene in Shanghai is contributed by the ladies whose commodity is love, cash and carry. Thibet Road between Avenue Eddie the Seventh and Nanking Road is practically infested with these charming ladies from the earliest sign of twilight until three and four in the morning. From one A.M. on, the region around Kiukiang Road and on over to Peking Road from Nanking Road is the hunting ground of the damsels and hunting ground it is. The weak of resistance are the prey of sometimes two and three of the gals who work in a concerted onslaught, grasping the victim firmly by the clothing and doing their best

to work him into a doorway or other place where they can compromise him to the extent that he loses face if he doesn't accede. Each girl is accompanied by an amah, who recites her protege's charms, virtues and accomplishments and otherwise negotiates with the clients. Meanwhile, the girl stands by and looks bored. On a warm evening hundreds of these girls are out, filling the street, giggling and wise-cracking at the appearance or demeanor of the male passers-by, horse-playing with each other like high school children while amah keeps a wary eye for customers and police. Sometimes the law puts in an appearance. Then all of the girls, like some startled colony of pygmies at the approach of a giant, take to their heels in a wild rush for doorways and basements and the midnight street is left to the sardonically smiling ricsha coollies, who smile because they know that the only advantage they have is that their trade is not unlawful.

SCHIFF

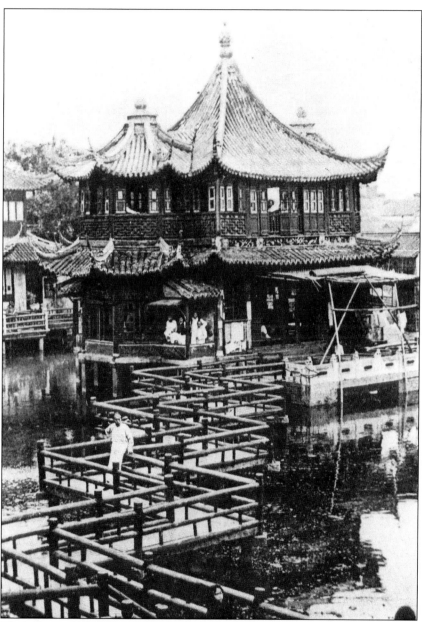

The teahouse and zig-zag bridge in the heart of the old city. Probably 1900s.

Sir Victor Sassoon

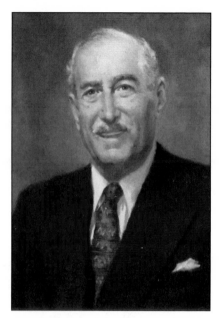

AN INVESTOR of Armenian Jewish ancestry, Sir Victor was one of the towering figures of the Shanghai scene from the 1920s through to the Communist takeover in 1949. He built many of the most imposing buildings of old Shanghai, and was a horse-racing fanatic who once remarked: "There is only one race greater than the Jews and that's the Derby." His ancestors came to power and wealth through the opium trade from India to China, and had their headquarters in Bombay. But in the late 1920s, Sir Victor transferred, as Fortune

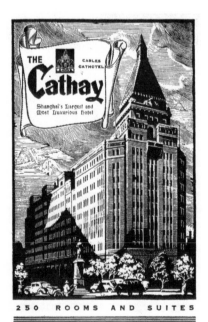

THE
Cathay

Shanghai's Largest and
Most Luxurious Hotel

CABLES
CATHOTEL

250 ROOMS AND SUITES

put it in 1935, "from Bombay to Shanghai about sixty lakhs of taels, which is roughly $85.000,000 Mex. (Mexican silver dollars)". He invested the money largely in land, real estate and hotels, and his gamble proved correct. He built the Cathay Hotel (now the Peace Hotel), and the Metropole and what is now the old Jinjiang Hotel, as well as Embankment House on the north side of Soochow Creek, the biggest building in China at that point. He had ambitious plans for the reconstruction of Nanking Rd, Shanghai's main shopping street, when the Japanese War intervened in 1937. When the Communists took Shanghai, Sir Victor was in New York. He commented: "I gave up India, and China gave up me."

Sportsmen

An excerpt from
Household Days in
China, *by J.O.P Bland,
published in 1906*

To do the Chinese peasant justice, he is usually a decent fellow in this matter of retrieving, especially in a country where foreigners do not shoot too often. To have one's bird deliberately lifted in the open by the Lord of the Soil was a new experience, another pernicious result, no doubt, of the "sovereign rights" movement. As a general rule, unless you happen to be in a district where so-called sportsmen have irritated the natives by tramping through their crops, the countryman will take a kindly interest in your proceedings, advise you where to find game, and help to retrieve a lost bird. And should you express appreciation with a ten-cent piece, you will be none the less welcome when next you pass this way.

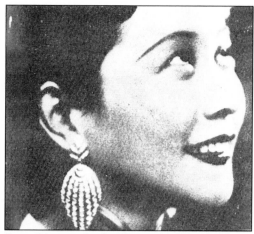

Ruan Lingyu, the female star in China's silent movies, including 'Goodbye, Shanghai'. She committed suicide in 1936.

The history of foreign diplomacy with China is largely a history of attempted explanations of matters which have been deliberately misunderstood.

> *Arthur H. Smith,*
> Chinese Characteristics, *1894*

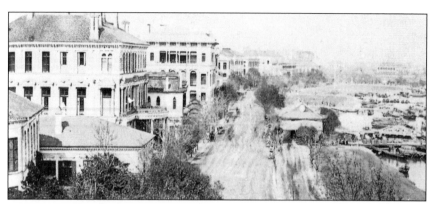

The Bund in 1880 looking northwards.

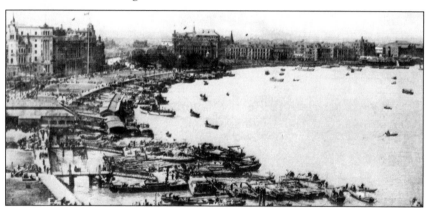

The Bund in the 1920s.

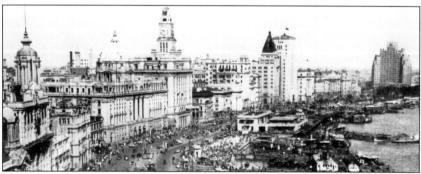

The Bund in the 1940s.

The Spartans

An excerpt from Letters of a Shanghai Griffin, *published in 1910:*

Shanghai is well provided (with social clubs). So far I have discovered the Masonic Club, open only to the members of that mysterious brotherhood whose ambition would appear to be passing through arches; the Junior Club, German Club, American Club, French Club, Italian Club, Portuguese Club, Country Club – the latter is run by masculine women and paid for by nice men with pink cheeks and long, silky eye-lashes – and finally the Ward Road Athletic and Social Club, commonly known as the "Spartans."

The last-named has, however, died an heroic death, owing to the fact that the members could not retain the services of either a medical man or a committee for a longer period than one week. It appears that one of their regulations was to the effect that any member must be prepared to get up and box four rounds at any hour during the night. If it was decided that a certain member was becoming slack, or soft, and not taking sufficient exercise, the committee would advance on his house in a body at about 3 a.m. with a set of boxing gloves, turn him out of bed, clear the room, and insist upon his doing his duty for the sake of his health and the reputation of the Club.

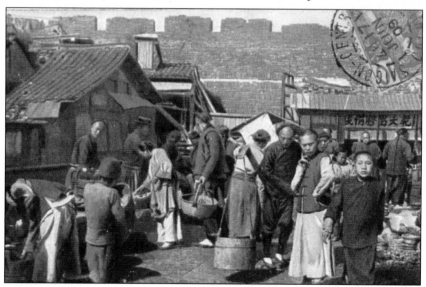

Inside the city walls around 1905. Chinese merchants requested they be pulled down in 1912, just after the fall of the Qing Dynasty.

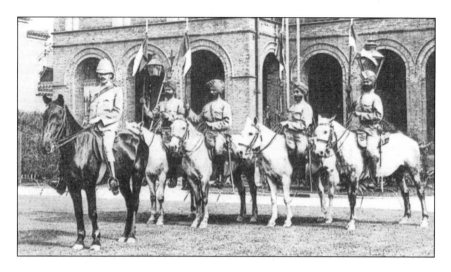

Indians in Shanghai

One of the stranger consequences of the Empire was the Indian community in Shanghai — policemen, doormen, and millionaires. The huge, bearded Sikh policemen were an imposing and frightening sight for the Shanghainese, who referred to them as "Red Head Number Three's". Why Number Three? The best explanation I have heard is that 19th century white British men were constantly exclaiming "I say!" to each other, and the Shanghainese heard it as "ah-se" in their language, meaning Number Three. The Indians were red-turbaned versions of the generic foreigner.

City-by-the-Sea

An excerpt from Vicki Baum's novel,
Shanghai 1937

The town emerged slowly out of the white morning mist, the gigantic town, the vicious town, the industrious, dangerous and endangered town of Shanghai, the City-by-the-Sea. Foreigners had raised it from the marsh and mud, they had made their pile with opium and smuggling, foreign fortunes had been squeezed out of the sweat and blood of the Chinese coolies. Now it had the wild years of its first youth behind it and was beginning to reflect, to learn refinement and to be a little ashamed of its past. Three and a half millions slept under its roofs, in skyscrapers, in mansions, in luxury hotels and on tattered mats, in boats, in good beds and in dirty, slimy corners. They slept, they dreamt and woke up, missionaries and millionaires, victors and victims, the blackmailers and the blackmailed. Factory sirens summoned the hands to labor, women, children and coolies streamed like beetles into the mills to spin silk and weave cotton. The early airplanes took the air and vanished into the sky. Soldiers drilled, porters carried goods to the quays, automobiles were washed, gamblers reeled from the clubs, losers and winners. Indian, French, Russian, Annamite and Chinese

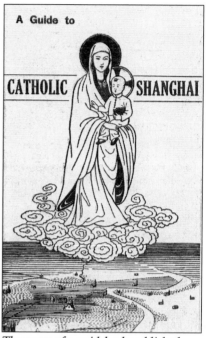

The cover of a guidebook published by the Catholic diocese of Shanghai in 1937. The Virgin Mary holds a Chinese child on a Chinese cloud. The Catholic Church ran a wide variety of operations in the city.

police kept order. Bands of thieves and burglars shared the booty of the night. Banks rolled up their shutters, night clubs closed. Sailors trooped back to their ships, and the brown sails of a thousand junks were spread. Craftsmen of every color and trade bent to their work. Tea was sipped from innumerable blue-and-white cups, and those who were too poor for tea drank

hot water. The merchandise of the whole world was unloaded in the port; Chinese compradors did business for foreigners, and foreign money stuck to their hands. At the gateway of that seething world called China, competitors thronged with their wares. Underground conflicts and briberies were carried on between smugglers and customs officials. Students poured into the universities to fill their bellies with foreign knowledge for the benefit of their country and their nation or to their own advantage and that of their clan and family. Muttering priests lit candles and incense, and people of all religions prayed before the altars of every faith. Buddhists, Taoists, Lamas, Catholics, Protestants, Mormons: Christians of every shade and sect scuffled for the souls of the Chinese; and salesmen of all nations scuffled for their money. Like foam on the city's turgid current swam the philosophers and poets, the journalists and learned men,

the writers, actors and artists. Ten thousand busybodies ran to and fro between the cultures of West and East, trying to act as go-betweens and explain the one to the other. Ten thousand castaways clung to the edge of society before they went under. Ten thousand who had made good gave them the last murderous push. Ten thousand others fought their way up step by step by infinitesimal degrees and imperceptible successes, with the tenacity of ants and their callousness. Many had come and vanished again. Many had struck root in the foreign soil, founded families and built homes and could no longer breathe any other air than the hot, moist, heavy air of Shanghai. The town gave out a mighty hum, the hum of ceaseless labor. It relied on the industry and sweat of the middle classes, whether white or yellow, those who were neither very rich nor very poor and whose part it was to live through the unceasing toil of the daily round. Their pleasures were simple and cheap: a visit to a cinema, a game of mahjong, a modest meal with friends. New China rioted with gigantic building schemes, with barracks, schools, sports grounds and airports. The old China lived in narrow alleys, echoing with the chanted cries of the coolies and peddlers; it hung birds before its doors, smoked water pipes, bargained and haggled, ate and slept, played and smiled, and was happy. Much blood has flowed

" POLICE DUTIES"

in its streets, for every war in the country must come to Shanghai. The city treated man as a stage play and shook bombs and destruction off as though they were all in the day's work. The foreigners had sown benefits and crimes in equal quantities over the city, and they had reaped much hate and very little gratitude. The foreigners despised and marveled at the Chinese. The Chinese despised and marveled at the foreigners. The foundations of the city were riddled with rats, conspiracies and secret societies. The warships of many nations lay at anchor in the river; their guns were not concealed but always ready and visible in war rig or in threat. Would the war come to Shanghai?

And if the war came to Shanghai, would the town be able once more to shake it off like a noxious or insignificant insect? From the West and South, Chinese soldiers by the hundred thousand were on the march. In the river six Japanese ships lay at anchor, in which thousands of soldiers had been transported through storm and typhoon to the mouth of the Yangtze Po. The stage was set, the play could begin. Newspaper boys roared the latest headlines in the streets. A little old Chinese sat smiling on the steps that led down to the water near the Bund with a tiny cage on his knees. In the uproar that shook the world he heard nothing but the fine clear summer voice of his cricket.

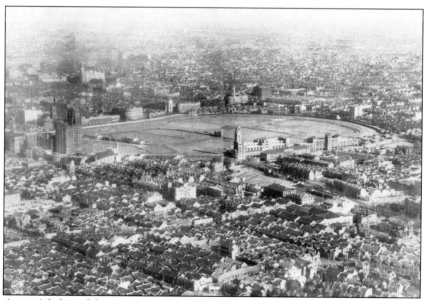

An aerial shot of the racecourse in the 1930s

Taiping Rebellion

The Taiping Rebellion of the 1850s and early 1860s, led by a school teacher who believed he was the second son of God and Jesus' younger brother, killed millions of people. The rebels threatened Shanghai three times in. The foreigners were for many years unsure of how to deal with the Taipings, who professed belief in a brand of Christianity which superficially seemed very similar to their own. But in the end they decided the Taipings were too weird, and that the civil war was bad for business. Foreign money and arms were thrown into the fight on the side of the Imperial army, and their contribution was crucial to the ultimate collapse of the Taipei rebellion with the capture of their capital at Nanking and the suicide of God's second son in 1864.

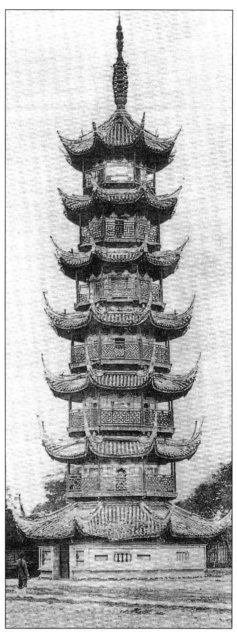

The Longhua Pagoda

28

Frederick Townshend Ward

Frederick Townshend Ward, an American adventurer from Salem, Massachusetts, arrived in Shanghai in 1860, just as the Taiping forces were threatening the city. Ward went to the Shanghai Taipans with a business proposal — he offered to create and lead a defence force if they would bankroll the enterprise. They agreed. His first step was to attack the Taiping rebels at Songjiang, about thirty miles southwest of Shanghai. The ragtag band of soldiers drank too much the night before, and the affair ended in farce. But his unit survived and was later instrumental in turning away the Taiping attacks on Shanghai. The Shanghai businessmen paid him well, and the Chinese Imperial Court was so overwhelmed with gratitude at his assistance in beating back the Taiping that his force was given the name "Ever Victorious Army". But the authorities of the Settlements were not so impressed. The Americans, who had adopted a policy of neutrality, objected to his actions. The British authorities were incensed because the temptation to join Ward's force and enjoy the plunder and mayhem led to many desertions from the Navy. In May 1861, Admiral Hope arrested Ward on the charge of enticing sailors to leave their ships and he was brought before the American Consul for trial. He secured his acquittal by declaring he had renounced his nationality and had become a Chinese subject. Ward rode into battle armed only with a riding crop. He went native, and apart from taking Chinese citizenship, also married a Chinese lady. He was killed by a stray bullet during an action against the Taiping rebels near Ningbo to the south of Shanghai on September 21, 1862. He was buried with his dog in Songjiang, where a Chinese temple was raised in his honour. He was thirty years old. Given the nature and reputation of Ward's army, General Gordon's tribute to him was a back-handed compliment at best: "He was a brave, clear-headed man, much liked by the Chinese Mandarins, and a very fit man for the command of the force he had raised."

The Disposal of Shanghai's Waste Products

*By Arthur De Carle Sowerby,
From* China Journal *August 1938*

China Journal
August 1938

Managing Editor:
Hubert Freyn
Editor: Bruno Kroker Ph.D.
Advisory Editor:
Arthur de Carle Sowerby
Manager & Secretary:
W.V.D. White
Offices:
20 Museum Road, Shanghai
Telegraphic address:
Jouchina, Shanghai
Telephone: 13247

IN MANY ways a city is like a human body. Not only does it need feeding, it also is necessary to its health that all waste products should be disposed of. In a great city like Shanghai the latter work is part of the functions of the Public Health and Public Works Departments. When anything interferes with this work the health of the community is soon impaired. The accumulation of waste products causes the outbreak of disease, rapidly spread by various agencies, especially flies, which under such conditions increase enormously in numbers. Not only does garbage and human and animal ordure have to be disposed of, but also the bodies of the dead, which, in the case of a city, must be considered in the light of waste products. If not properly dealt with these may soon become an even greater menace to the health of a community than decaying refuse.

Last autumn and winter, with a war raging all round the International Settlement and French Concession in Shanghai, the means of disposal of both refuse and human corpses, of which there was an enormous increase above normal, were seriously curtailed. The difficulty was further increased when Japanese forces completely encircled the Settlement and Concession, and the war moved westward.

The Soochow Creek, one of the main channels along which ordure and garbage was carried away from the dry, was blocked. Also there were no means left of getting rid of the city's dead, which accumulated in various vacant lots within the city limits. In the Hongkew and Yangtzepoo areas north of the Soochow Creek, in the Hungjiao and other areas west of the Shanghai-Hangchow Railway line and in the Chapei area the bodies of the large numbers of people killed in the hostilities were for the most part left where they fell. This was also the case with the numerous carcases of animals that were killed.

Thus the Public Health and Public Works Departments of both the International Settlement and French Concession were faced with an unprecedentedly difficult and stupendous task in disposing of the city's waste products, human and otherwise. That they have succeeded in that task in the face of so much difficulty is greatly to their credit. It is also greatly to the credit of the Chinese members of the community that they have agreed to abandon their age-old customs and beliefs in regard to the disposal of their dead and allowed the latter to be cremated instead of insisting on their being buried. This has enabled the Public Health Department satisfactorily to dispose of some tens of thousands of dead bodies. Those of the International Settlement have, since January when the work started disposed of 34,801 bodies.

It seems to be the popular belief that the majority of these were the bodies of people killed during the hostilities and salvaged from the war-stricken areas. This, however, is not the case. Such bodies only numbered some three thousand or so. The remaining 31,801 corpses dealt with were those of people who had died in the Settlement area during the hostilities and could not be buried, and of those who have died in the Settlement during the past months since hostilities ceased in this area.

It may be noted that the Settlement authorities are still

experiencing much difficulty in disposing of the city's garbage and ordure, being hampered by restrictions placed on the free transport of such material along the Soochow Creek and other channels away from this city. Epidemics of cholera and other infectious diseases have broken out in the Settlement and Concession, and the health authorities are busily engaged with inoculation campaigns. The Japanese military forces in and round Shanghai are also similarly engaged, and have issued regulations preventing people entering the areas under their control who can not produce certificates to the effect that they have been inoculated against cholera.

A Lazy Lot

From China Journal,
August 1938

Insect Pests Bad this Year in Shanghai: In Shanghai gardens insect pests have been unusually bad this year, especially the caterpillars of various kinds of butterflies and moths. Many shrubs have been thickly infested with the stinging caterpillars of satin moths, while rose bushes and vines have been completely stripped of their foliage by the caterpillars of a certain small moth that looks more like some form of bee or wasp. These pests are extremely difficult to get rid of, even with the use of various well known insecticides sprayed over the plants. Sprays that are made up with petroleum as a base are very effective, but our experience is that they also damage the foliage to such an extent that one might just as well have let the caterpillars devour it. Our own method of dealing with these pests is to watch for them and remove them when they appear. But this can hardly be done on a large scale, especially with our Shanghai coolie-gardeners, who are a lazy lot.

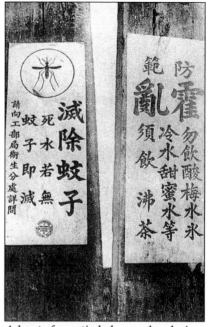

Adverts for anti-cholera and malaria remedies

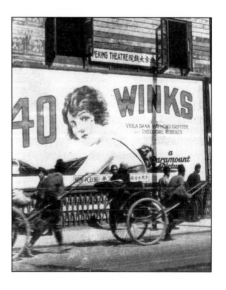

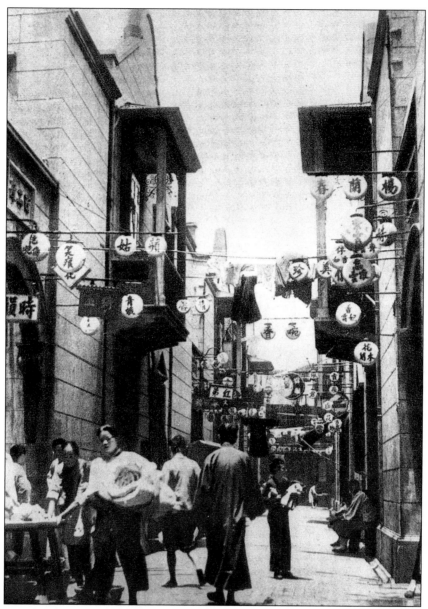

*An alley in old Shanghai famous for its prostitutes and brothels, taken probably
in the 1920s. The signs mostly show the names of the girls.*

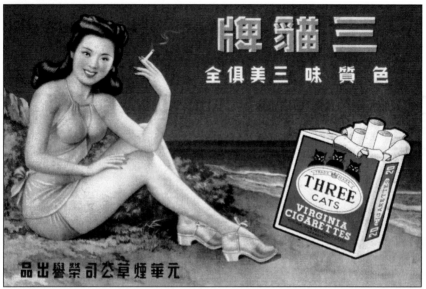

Her name, I am sure of it, was May-May

"High hats and low necks; long tails and short knickers; inebriates and slumming puritans. Wine, women and song. Whoopee! The throb of the jungle tomtom; the symphony of lust; the music of a hundred orchestras; the shuffling of feet; the rhythm of abandon; the hot smoke of desire under the floodlights; it's all fun."

1930s Shanghai guidebook

A woodblock print of the China Merchants' docks and warehouses in Shanghai in the late 19th century. The ship is one of their fleet. China Merchants was China's first effort at matching the West commercially.

Narrow Dirty Streets

An excerpt from Jules Verne's novel, The Tribulations of a Chinese Gentleman, *published in English in 1883. He never visited the city.*

Shang-Hai proper is situated on the left-hand bank of the little Wang-Poo River, which, meeting the Woosung at right-angles, joins the Yang-tse-Kiang, or Blue River, and ultimately flows into the Yellow Sea. The town is oval in shape, lying north and south, enclosed by high walls, through which five outlets lead to the suburbs. The narrow dirty streets are little better than paved lanes; the dingy shops, without fronts or stocks to attract, are served by shopmen often naked to their waists; not a carriage nor palanquin, and very rarely even a horseman, passes by here and there are scattered a few native temples and chapels belonging to foreigners; the only places of recreation are a "tea-garden," and a swampy parade-ground, the dampness of which is accounted for by its being on the site of former rice-fields. Such are the chief points of a town, which, undesirable as it may seem as a place of residence, yet numbers a population of 200,000, and is of considerable commercial importance.

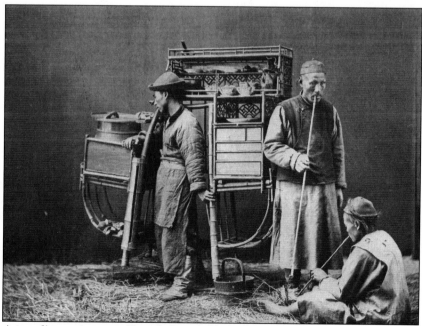

A traveling restaurant, Shanghai, probably in the 1870s

35

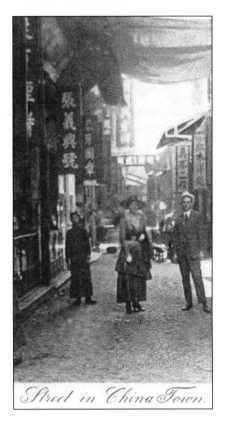

Street in China Town.

A City of Gardens

Jesuit priest Father Matteo Ricci, describing Shanghai c. 1610

The walls are two miles compasse, the Suburbes contayne as many houses as the Citie; so that there are numbred fortie thousand Housholds ... the Territorie is an even Playne, and so cultivated that they seeme a Citie of Gardens, full also of Villages, Hamlets, Towers. There are many good wits and Students, a good Ayre, and they live long, eightie, ninetie, and a hundred years.

'Religion,' say the Russians, 'the opium of the people.'

'Opium,' assert Chinese cynics, 'the religion of the people.'

Edgar Snow,
Far Eastern Front,
1934

Pidgin English

Foreigners in Shanghai almost never bothered to learn the language of the natives — many Shanghailanders were born and raised in the city and never spoke a word of Chinese, and those who did learn to speak some were considered slightly weird. They communicated with their Chinese servants and other menials in Pidgin English, a bastardised China Coast pot-pourri of mangled English, Chinese, Portuguese and Indian words.

Pidgin Lexicon

Blong — is, are, belong to, etc.
Bottom-side — downstairs
Bym-bye — later
Catchee — Have, get, bring
Chop-chop — quickly!
Chow — food
How fashion? — what for? why?
Kumshaw — a tip
Largee — much, great
Likee — to like
Look-see — look, appear like, see
Makee — make, do, cause
Maskee — never mind
More betta — better
Muchee — very
My — my, me, I
No can — I cannot, impossible
Number one — very good
One piecee — a, an, one
Plenty — much, very, very much
Savvy — know, understand
Side — place, country
Solly — sorry
Talkee — tell, say, inform, ask
This side — here
Topside — upstairs, on top
Walkee — to go
Wantchee — to want
What for? — why?
What fashion no can? — Why not?
What-side — where?

Pidgin Poems

A yellow taxi comes in view.
The weary chauffeur asks, "Where to?"
What would result if you replied,
"Make walkee chop-chop Broadway side?"

You'd wander down Fifth Avenue
To look at frocks as women do
Or try on hat to spend your cashon —
"Wantchee more better, proper fashion."

When we go home, I wonder whether
We'll lose our pidgin altogether?
I'd like to keep a little bit.
I find I'm rather fond of it."

———————————————

It was popular to translate famous pieces of poetry into pidgin. Here is Longfellow's Excelsior:

The original version:
A youth who bore through
Snow and ice
A banner with a strange device
"Excelsior".

The pidgin version:
One young man walkee, no can stop
Maskee de snow, maskee de ice!
He carry flag with chop so nice
Topside galow!

Pidgin Joke

The Hall Porter at the Shanghai Club answers the phone.
Female Voice: "That belong Hall Porter? Well, my wanchee savvy, s'pose my husband have got, no got?"
Hall Porter: "No, missy, husband no got."
Female Voice: "How fashion you savvy no got, s'pose my no talkee name?"
Hall Porter: "Maskee name, missy, any husband no got this side anytime."

The Wisdom Of Satan

Pidgin poem from China Coast Ballads
by Shamus A'Rabbit

Missie Bubbling Well
In Hop Sing's shop
"Wanchee one piecee meat
No wanchee bone
No wanchee grizzle
No wanchee fat
No wanchee skin."
Hop Sing talkee
"Missy me thinkee
More better you catchee
One piecee egg."

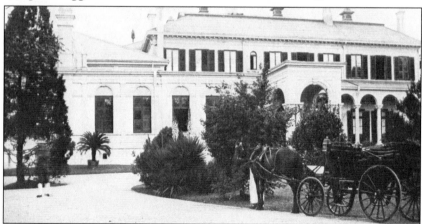

A Shanghai country club, out of bounds to Chinese people unless they were servants.

39

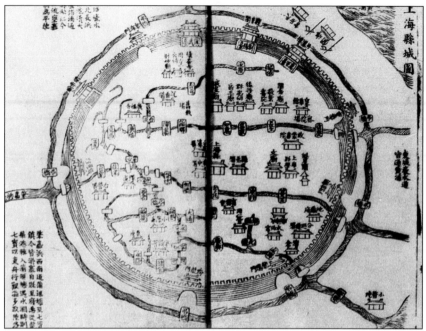

A Chinese map of Shanghai during the 16th century. It was a small county seat, a walled fishing town. The Huangpu River is top-right

The Illustrated London News described the capture of Shanghai in June, 1842 thus:
"The battleship Nemesis ... set fire to the city of Shanghai which was occupied by our troops, its public buildings burned, its rich granaries, the property of the government, given up to the people. An incessant cannonade was kept up for two hours ere the enemy showed any symptom of submission."

40

Public Garden

Letters to the editor, North China Herald, May 1911

SIR, I am at a loss to understand why the rule boards at the Public Garden should have been repainted some time ago. They seem to be quite useless anyhow, and nobody is there to enforce them. Could they not be removed altogether?

"No Chinese shall be admitted." This rule seems to exist for all but for the missionaries. They very often bring their native friends along with them, women as a rule, who are no amahs in attendance of foreign children. They occupy the chairs during the time the band is playing and when chairs are scarce. During last year they used to come at least twice a week.

No dogs allowed in the Public Garden. Yesterday I counted, during the 5 o'clock concert: 1. A small girl with a terrier pup. 2. A man with a pointer dog. 3. Three sailors with a setter. 4. An old lady with a terrier. 5. A lady with a young terrier. 6. Two ladies with a Japanese dog.

Many things have changed and have been altered during the last year in Shanghai. Perhaps the above rules are also to be done away with quietly. If so I shall be pleased to take three dogs to the concerts also, and then, you shall see some fun.

I am, etc., "DOG OWNER"
Shanghai, May 24.

SIR, "Dog Owner" notes the presence of Chinese ladies in the Public Garden, brought thither by their missionary friends. He calls public attention to the non-enforcement of the by-law which proclaims that no Chinese (ladies or gentlemen) shall be admitted to the Public Garden.

So long as certain Chinese, in the shape of amahs, and other less desirable Asiatics and occasional non-descripts are permitted freely to throng our Public Gardens and parks, any invidious allusion to the foregoing by-law is both indiscreet and unnecessary. It is a matter for the quiet attention of those whose duty it is to see the Municipal by-laws enforced.

"Dog Owner" would have done well to confine himself to dogs only.

I am, etc.,
"CONSIDERATE"
Shanghai, May 25

> Shanghai is the city par excellence of two things, money and the fear of losing it.
> *John Gunther*, Inside Asia, 1939

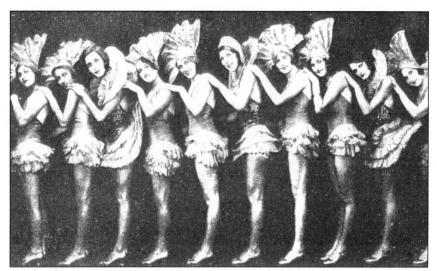

A line of White Russian dancers

Hotel Whores

"This town would ruin anybody in no time. The babes that twitch around the hotels need attention so badly that it is hard not to give it to them."

Joe, later Lieutenant General Joseph W. Stilwell, on Shanghai in 1923

"WHY YOU NO MAKE YORKSHIRE - PUDDING?"

"MISSIE - MARKET-SIDE NO CAN CATCHEE YORKSHIRE!"

"If God lets Shanghai endure, He owes an apology to Sodom and Gomorrah."
A Christian evangelist in the early 1920s

"Nowhere in the world, I should think are there so many cabarets in proportion to the total white population. They range from the cheap and respectable palais de danse to more select resorts with exotic names like 'Paradise,' where beautifully dressed professional dancers, mostly Russian, obligingly dance with all comers on the sole condition that they order champagne."
An English journalist in 1927

Shanghai fashion around 1910

43

Origin of the Municipal Seal

From The North China Herald, July 8, 1916

The following notes from a correspondent of antiqiarian tastes will be of interest to many who have wondered how the Municipal Seal came into existence.

The Municipal Seal at present in use was designed by Mr Oliver, the then Municipal Engineer. It was approved by the Council in December, 1868 and brought into use in April, 1869. At that time 11 countries had treaties with China. These, in the order of the dates of their treaties, are as follows: Russia, Great Britain, America, France, Belgium, Sweden and Norway, Germany (i.e. Prussia), Denmark, Netherlands, Spain, Italy. With the exception of Belgium the flags of all these countries are included, whereas Austria and Portugal are represented, although they apparently had no treaties.

The flags represented are as follows:

Top left hand shield: Great Britain, America, France, Germany.

Top right hand shield: Russia, Denmark, Italy, Portugal.

Lower Shield: Norway and Sweden, Austria, Spain, Holland.

Countries having treaties with China but whose flags are not represented on the shield are: Belgium, Japan, Cuba, Brazil.

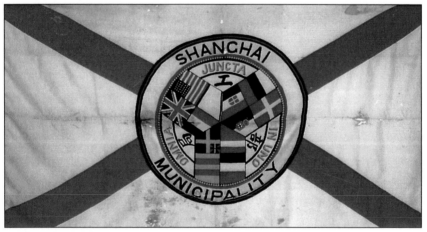

The flag of the Shanghai Municipal Council, whch ran the International Settlement on behalf of (theoretically) the interests of a host of different nations. The British dominated, but Shanghai was never a British colony.

Spoilt Children

"The British residents in Shanghai
are the spoilt children of the Empire.
They pay no taxes to China, except
that landowners pay a very small
land tax, and no taxes to England.
Judges and consuls are provided
for them; they are protected by the
British fleet, and for several years
they have had in addition a British
army to defend them; and for all
this expenditure the British taxpayer
pays."

L. A. Lyall, 1930s

Girls or Boys

Christopher Isherwood, Journey to a War, *1939 with W.H. Auden*

Nevertheless, the tired or lustful business man will find here everything to
gratify his desires. You can buy an electric razor, or a French dinner, or a well-
cut suit. You can dance at the Tower Restaurant on the roof of the Cathay Hotel,
and gossip with Freddy Kaufmann, its charming manager, about the European
aristocracy, or pre-Hitler Berlin. You can attend race-meetings, baseball games,
football matches. You can see the latest American films. If you want girls or
boys, you can have them, at all prices, in the bath-houses and the brothels. If
you want opium you can smoke it in the best company, served on a tray, like
afternoon tea. Good wine is difficult in this climate, but there is whisky and
gin to float a fleet of battleships. The jeweller and the antique dealer await your
orders, and their charges will make you imagine yourself back on Fifth Avenue
or in Bond Street. Finally, if you ever repent, there are churches and chapels of
all denominations.

Shanghai Country Walks

Preface to Second Edition in 1934 when the fields were within walking distance of central Shanghai

The country around Shanghai holds out few of the conventional inducements to the walker, but offers others which well compensate for the lack of them. There are no fingerposts to guide nor fences to obstruct one; no dusty stretches of road, but innumerably quiet streams. The only certainty is the unexpected, and what more, if the walking is good and the country people are amiable, can the good walker desire?

Riders and house-boaters explored and began mapping it half a century ago and their memories of the Far East will be inseparably connected with rural China rather than with crowded Shanghai streets. The author of "Shanghai Country Walks" has carried on the work in this varied selection of excursions into the Western country, which will appeal to all lovers of the open air. Comparatively few of us have tramped the country to any extent on foot; those who have are gainers in health and experience, but profit even more in acquiring some knowledge of Chinese life and customs and a better understanding of its people.

The remark too frequently heard - "Oh, Shanghai isn't China !" - may be true enough, but it does not apply to the country a few miles from the Settlement boundaries. Many of us have no opportunities for travel in the interior of China, but we have at hand, with the aid of this little book, ready-made excursions into China

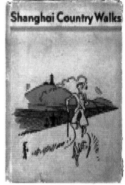

and opportunities for observation that will take the sting out of the ancient taunt.

Is it safe? In the experience of the author and of many others of us who have been riding and walking in the country for years, its people are either uninterested in or friendly to the foreigner; one's attitude — whether inconsiderate or sympathetic — is usually reciprocated. The only confirmed antagonist of the foreigner is the Chinese wonk (dog), but his bark is worse than his bite and a walking stick will keep him at a safe distance ...

... Not even the greatest optimist can claim that the Shanghai district is a happy hunting-ground for the lover of country walks, but in spite of the ever-encroaching builder, I can at least state that pleasant walks are to be found if the pedestrian

is prepared to put up with a few of those little inconveniences which are, perhaps, given more prominence than they deserve. Take, for example, the Chinese method of raising crops — but I think I can better describe this by quoting the classic words of Jay Denby in his "Letters of a Shanghai Griffin":

"I must inform you that their (the farmers') time is spent mainly in the vocation of agriculture, the chief productions therefrom being smells, graves, and rice, in the order named. China is the country of the small landholder, for land, being difficult to steal, is looked upon as the only really safe investment ... the farmer who succeeds in making his land smell more abominably than his neighbour's is looked upon with respect, admiration, and envy by the surrounding population."

I must agree with Mr. Denby that there are smells. There are also dogs (locally known as "wonks"),

narrow paths, much mud (at times) and a general flatness, all of which, when combined, are not conducive to enjoyable walking. But my reply to the detractors of our countryside is that the smells are only apparent among certain crops at certain times; that dogs may be to a great extent avoided by learning to avoid the villages; that narrow paths are quite convenient if you will learn to walk and talk in "Indian file"; and that there is a certain pleasing restfulness about flat country if you will try to cultivate the taste for it ...

... May I first try the patience of the reader by enumerating a few things to be borne in mind when walking in Chinese country.

"DON'TS."

DON'T go about in large and noisy parties which will attract too much attention. Small parties moving quickly do not attract crowds; they also avoid the probability of mild "rags" which may lead to unpleasantness.

DON'T carry firearms of any sort; they are unnecessary and will get you into trouble whatever happens.

DON'T throw stones at dogs if you can avoid it. The population of China has a habit of popping up in unexpected places and if you hit someone by accident you are asking for trouble ...

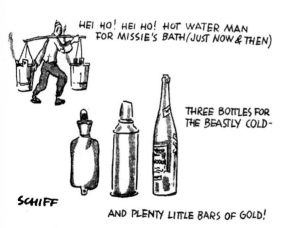

HEI HO! HEI HO! HOT WATER MAN FOR MISSIE'S BATH (JUST NOW & THEN)

THREE BOTTLES FOR THE BEASTLY COLD—

SCHIFF

AND PLENTY LITTLE BARS OF GOLD!

Cynicism Sweetened Air

An excerpt from Peter Quennell's 1932 book, A Superficial Journey Through Tokyo and Peking, *reflecting on the differences between Japan and China:*

I remembered, with my back against the wall, scenes of the same kind in other countries – a tea-house, for example, in Shanghai, to which we had been taken one evening by a Chinese guide, a stout ruffianly man scarred with smallpox. It was a huge room, looking out onto a busy street, full of women sitting round little tables; to every three or four girls an ancient governess, like a peasant-woman who has brought pigeons to sell at a fair ... By comparison, what a refreshing informality! The young women, girls of fifteen and sixteen, wore trousers and short pyjama coats, dull blue, over white socks and little satin slippers. None was attractive, but the indistinguishable mass chattered as glib and bold as a crowd of schoolchildren. They pulled and stroked our clothes as we went by, unafraid and unabashed, almost indifferent. No taint there of this agonizing propriety. Flesh was flesh, sold and bought – bought and enjoyed. The effect might be sinister but it was also friendly; the very cynicism of the whole proceeding sweetened the air ...

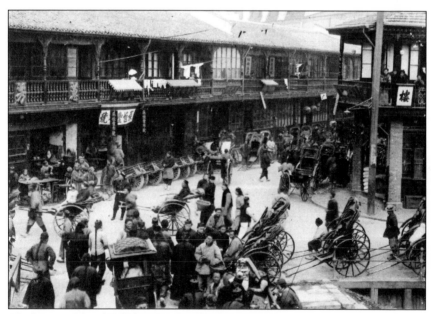

The intersection of Jinlishui Road and Renmin Road.

Taipans

"A taipan, let me explain, is a red-faced man (the redder the face, the taipanner the taipan) who has either sufficient brains or bluff to make others work for him and yet retain the kudos and the bulk of the spoil himself."

Jay Denby in his book
Letters from China

Derivation of "The Bund"

An excerpt from The Streets of Shanghai, *published in 1941:*

The first streets running west from the Bund were originally named in alphabetical order to make them easy to remember; thus we have CANTON, FOOCHOW, HANKOW, KIUKIANG, NANKING, PEKING and SOOCHOW ROADS in the order named: at a later date JINKEE ROAD, between Nanking and Peking Roads was turned from a private road, leading to Gibb, Livingston & Co. Ltd. (1846) whose Hong name is "Jin Kee", into a public road, and as the alphabetical order had been forgotten, the name was not changed.

THE BUND is of course the oldest road as it was the towpath, but where did THE BUND get its name? "Bund" is a Hindustani word meaning "a made embankment on a water front" and it was so christened by the early settlers from the East India Coy. Another link with the East India Coy, is AMHERST AVENUE called, as were the rocks on which she foundered, after the ship "Lord Amherst" that brought, in 1832, the first plenipotentiary of the E. India Coy., with the Rev. Charles Gutzlaff as interpreter, to Shanghai after foreign trade had been interdicted for three centuries.

The Goddess Quench

from China Coast Ballads *by Shamus A'Rabbit, 1938*

From Shanghai bound for Hongkong
Through sweltering heat we sail
We dream of Pilsener tankards
On good old Loyal Mail.

We chug down China's coastline
Where salamanders play
With dripping perspiration
The order of the day.

We hear the clanking fire-irons
As lascars stoke the coal
In Hades' firey furnaces
'Adown the dirty hold.

We hear the rumbling engines
That thump with every stroke
The parched epiglottis
Now makes us think we'll choke.

Then Fritz the greasy steward
Brings pilsener hot as hell
We order him with orders
To ice and cool it well.

We go with others smiling
Into the hot saloon
For Sunday morning services
To last from ten till noon.

'Tis thus we go to services
The hottest day at sea
To please the maiden passengers
Whose heroes we would be.

But as the doughty chaplain
Is leading us in prayer
Fritz calls us through the port-hole
And "Cool Beer!" rends the air.

The Shanghai Steam Laundry

A letter to the editor of the North-China Daily News, May 23, 1900

SIR: For very many years the foreign residents of Shanghai have had to submit to having their clothes washed by the native laundry men according to the rough methods adopted by them. Formerly there was no help for this, so foreigners endured the evil as cheerfully as possible without enquiring too closely as to the process through which their linen passed, though the rapidly destroyed shirt fronts, cuffs and collars caused much forcible language to be used.

From this condition of affairs, with few exceptions, there was no chance of escape, and therefore foreign residents put up with it as philosophically as possible, while occasional cases tried at the Mixed Court let them into the secret that the native washermen were fond of wearing their customers' underclothing, and there was, besides, a somewhat confused idea that the washing of their garments was not conducted on strictly sanitary principles.

But when, in January, 1898, Dr. Macleod made his famous report to the Municipal Council on the prevailing system of washing clothes in Shanghai, the horrible state of affairs he then disclosed came as a severe shock to the foreign community and it was rightly felt that some change for the better was imperative. The Council made an attempt to control the native washermen and to insist upon the work being performed more decently than was customary with them, but the disinclination of the native washermen to admit reforms caused the project to fail.

There was then a fine opportunity for foreign enterprise, and this was taken advantage of with as little delay as possible by certain residents. It naturally took some considerable time to collect the information necessary to lay before the public, but in October last year the promoters of a Steam Laundry Company were in a position to issue a prospectus for its formation and the required capital was at once subscribed ...

From the very first the opposition of the native washermen was excited, and they have been industriously at work to try and ruin the Company's business by the underhand actions in which Chinese are such adepts, their principal efforts having been directed towards bribing the native employees of the Company to spoil and disfigure the clothes of their customers after passing through the wash.

Strange as it may appear, there are still many foreign residents in the Settlement who are unaware of the existence of the Company, and it is chiefly with a view to dispel this ignorance that these lines are written, as the health of this community largely depends upon the progress made by the Steam Laundry Company.

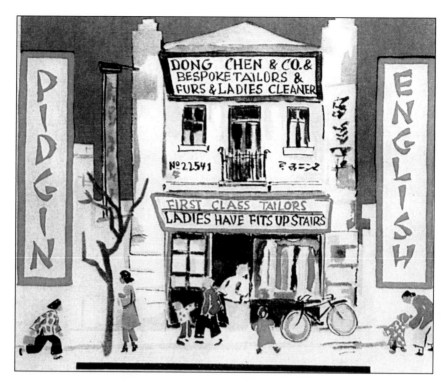

A Rival to Canton

Excerpts from Three Years' Wanderings in the Northern Provinces of China, *by Robert Fortune, British botanist, who visited Shanghai a few days after the city was declared open to foreign trade in November, 1843.*

Shanghae is by far the most important station for foreign trade on the coast of China ... No other town with which I am acquainted possesses such advantages; it is the great gate – the principal entrance, in fact, to the Chinese Empire ... Taking, therefore, all these facts into consideration, the proximity of Shanghae to the large towns of Hangchow, Soo-chow, and the ancient capital of Nanking; the large native trade, the convenience of inland transit by means of rivers and canals; the fact that teas and silks can be brought here more readily than to Canton; and, lastly, viewing this place as an immense mart for our cotton manufactures, which we already know it to be, there can be no doubt that in a few years it will not only rival Canton, but become a place of far greater importance.

A postcard from around 1900

Dr Gilbert Reid (far right), who arrived in China as a missionary in 1883. Photographed here with the orphans he looked after

Two Shanghai Courts

The main foreign powers all maintained their own courts of law in Shanghai to try cases involved citizens of their countries, who were exempt under the rules of extraterritoriality from being beholden to Chinese courts of law. This is an excerpt from an article published in the North-China Herald of February 5, 1904 describing the British and American courts:

His Britannic Majesty's Supreme Court at Shanghai is holden in the Consulate building. A spacious, lofty chamber, with a high seat for the Chief Justice, a low seat for the Registrar, a bench for the bewigged and begowned Advocates, another for the Press corps, a raised rostrum for the witnesses, and adequate accommodation for the public, it is something like a court of law. The aged-looking woodwork, the green baize, the tall windows, the churchy atmosphere, all seem in keeping. At the most, the voices of those who wait rise to a sibilant whisper. Suddenly a hush, and the warning announcement by the Usher: "The Court!" All rise, as a delightfully legal and humanly nice old gentleman proceeds to the throne of incarnate justice. He bows, seats himself, and the others do likewise. . . All is said and done subduedly, quietly, and one has the feeling that a sneeze or a cough would be almost contempt of Court, and entail some serious penalty . . . Our American cousins, now! They are men, shrewd, common-sensible, men of business, who have ridden themselves of encumbering ceremonial as so much childishness. Let us now visit an American court.

The U. S. Consular Court at Shanghai "happens" in a back room of a brick building in the Whangpoo Road. The furniture is Quakerishly simple. Item, a plain table with two rows of wooden chairs. In one corner a metal stove. Across one end of the table is a dais, and upon that a narrower table, with three chairs beside. Opposite the stove, a new looking "stand" for witnesses, with a chair in which they sit upon the "stand." Two gentlemen in lounge suits stand beside the stove, while another similarly attired asks them to "hold up their hands." He holds up his, too. and a murmur is heard. We understand they are being sworn. In comes a nice-looking, keenly intelligent-looking, old gentleman wearing a black skull cap tightly drawn over his white hair, and he shuffles on to the dais. He coughs, and the two American citizens climb up, one of them with his hands in his pockets, and flank him. The official who made them swear takes a shovel and stokes the stove, noisily. He makes us swear, almost, for we could not hear the names of the parties interested.

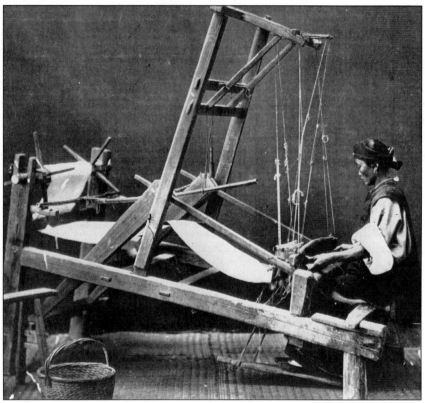

Textile production in Shanghai, around the 1870s

Shanghai is the richest prize of
the whole country for whatever
Chinese military and political
faction may be able to seize and
control it.

American consul-general, 1927

56

Du Yue-sheng

"Big Ears" Du was one of the key characters in Shanghai's life from the early 1920s through to the Communist take-over in 1949. He was a triad king who had his base in the French Concession.

He was born in a poor village near Shanghai and as a young tough, he joined the Green Gang, one of the main underworld societies of Shanghai and rose to become its leader and the ultimate Chinese Godfather. One of his favorite phrases was "You have my word". The Green Gang handled the usual enterprises such as gambling dens, prostitution, and protection rackets. Opium dens were still a major attraction and the French Concession with its more lax supervision became the heart of the opium trade by the 1920s. Du established a profitable relationship with the senior Chinese officer in the French police, Huang Jinrong. In 1927, Du ordered his Green Gang fighters to side with the Nationalists and turn on the Communists who had participated in an uprising in the city.

W.H. Auden and Christopher Underwood described Du in 1938:

"Du himself was tall and thin, with a face that seemed hewn out of stone, a Chinese version of the Sphinx. Peculiarly and inexplicably terrifying were his feet, in their silk socks and smart pointed European boots, emerging from beneath the long silken gown. Perhaps the Sphinx, too, would be even more frightening if it wore a modern top-hat."

He escaped to Hong Kong just ahead of the Communists in 1949 and died there in 1951.

Du Yue-sheng's entry in the Shanghai Who's Who *of 1933:*
"Better known as Dou Yu-seng. Born 1887; native of Shanghai. Entered business at an early age. At present most influential resident, French Concession, Shanghai. Well-known public welfare worker. 1932 councillor, French Municipal Council. President, Chung Wai Bank, and Tung Wai Bank, Shanghai. Founder and chairman, board of directors, Cheng Shih Middle School. President, Shanghai Emergency Hospital. Member, supervisory committee, General Chamber of Commerce. Managing director, Hua Feng Paper Mill, Hangchow. Director, Commercial Bank of China, Kiangsu and Chekiang Bank, Great China University, Chinese Cotton Goods Exchange, and China Merchants Steam Navigation Co., Shanghai, etc., President, Jen Chi Hospital, Ningpo."

Between China and England

An excerpt from Vicki Baum's novel, Shanghai 1937

Dusk was descending as the automobile bore them away and soon deposited them at an airport. Dr Chang crammed them into a little airplane which was already waiting for them. Bobbie was so paralysed that there was no more kick left in him. They hovered over the immense city while the lights crept out below in the reddish haze.

Bobbie flopped in his seat like a man shot dead. Helen had the sights pointed out to her.

The banks and skyscrapers along the Bund looked very small; Soochow Creek was only a thin, brown band between China and England. The French quarter nestled up to the International Settlement, and more and more lights twinkled out below. On the other side of the Creek lay Hongkew, a large expanse with its green patches of parks; Chapei, a maze of small streets in which the quadrangle of factories with their tall chimneys stood out.

More factories on the other side of the Whangpoo in Pootung. Yangtze Po, following the bend of the Great River, with piers gripping the water like narrow clasps. A gray patch forming an irregular circle, ribbed with innumerable roofs, was the old Chinese town in the center, bounded by the dotted lights of a main street on the side of the International Settlement. Another watercourse separated Nantao in the southwest from the French quarter; new suburbs stood out vividly and with green garden plots and unbuilt sites. Far away to the southwest the city was lost in haze beyond the arsenal and airdrome. The innumerable junks on the river looked like sluggish brown beetles, between them the warships of all nations lay motionless, hung with delicate chains of light. By degrees the dusk sucked up every outline and left only the lights suspended in the haze.

ADDRESS: 376/8 NANKING ROAD, 11, SHANGHAI, CHINA.
TELEPHONE NOS: 91245 97444
地址：上海 (11) 南京東路三七六至三七八號
電話：九一二四五 九七四四四

The Coolie Class

"Though Shanghai is spoken of as a Model Settlement from the administrative point of view, it is far from being so from the sanitary point of view. The agricultural methods of the Chinese farmer and gardener, the personal habits of the coolie class, the great congestion and overcrowding in certain areas, the existence of foul and stagnant creeks, these are conditions incompatible with an ideal sanitary environment."

Shanghai municipal government report, 1930s

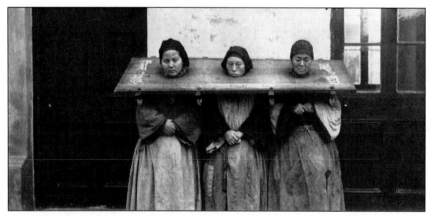

Three women in the cangue, Shanghai, 1907. It was used as a punishment for offenders convicted of petty crimes.

East of the Poo

From Shanghai by Night & Day, *Shanghai Mercury, c. 1920*

It is by no means an uncommon thing for a great city to be divided into two parts by a river running through it. London proper is so divided from Southwark; and Buda, the great Hungarian city, from Pesth. We have always expected that something of the kind would occur in Shanghai, but comparatively few people know that a beginning has already been made. The International Mill stands out for itself, so do the larger godowns higher up, but the Pootung town – there is one – is modestly hidden from the view of the dwellers on the western side of the river …

The cotton mill dwarfs everything near it. Its busy hum is heard all round, but the most interesting event to a visitor who looks on from the outside is the exit of the day shift and the entrance of the night workers. At six sharp the whistle sounds. Three or four men who have evidently been waiting just inside the doorway, are down the steps before two seconds are gone, and then for five minutes the great building empties its living hive. The engines stop, the hum ceases. Out pour the women in a continuous stream four deep. They seem very orderly, and the red-topped Sikh on duty has no need to exert his authority this time. For full five minutes the stream flows on, and one begins to wonder when it will cease. Then, except for a few laggards, the outgoing crowd ceases, and the night shift which has already collected outside enters. These are fresh: they are at the right end of their twelve hours spell to be frisky, and a good many of them apparently are boys. These enter with a rush, a roar, and a scramble, the Sikh after them, doubtless on corrective thoughts intent. The elders follow quietly enough. They stream in in twos, threes, and fours, and ere long the respite ends and toil begins once more.

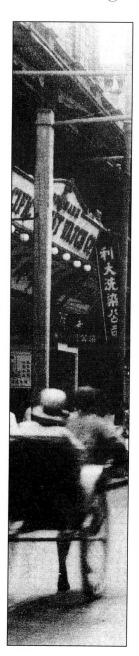

Extra-Territoriality

The treaties imposed on China in the 1840s allowed foreigners to do business in the "treaty ports," as the cities opened to foreign commerce were called. The treaties, as the foreigners interpreted them, allowed foreign settlements to grow up which were effectively outside Chinese jurisdiction. The treaties gave foreigners immunity from most Chinese taxes and allowed foreign troops to be stationed in China. They allowed missionaries to propagate Christianity freely. And the treaties gave foreigners the right of extraterritoriality, remaining subject to the laws of their own country rather than the laws of China, and it was this right that lay at the center of foreign privilege in China. (Paraphased from Clifford's *Spoilt Children of Empire*). There was continual friction between foreigners and the Chinese with the foreigners refusing to recognise the authority of the local law courts in matters involving themselves. The Treaty of Nanking in 1842 hinted at British subjects being under the jurisdiction only of the local British consul, but the terms of Extraterritoriality, under which foreigners were completely exempt from Chinese control were only fully clarified in a treaty between China and the United States in 1844:

"Subjects of China who may be guilty of any criminal act towards citizens of the United States shall be arrested and punished by the Chinese authorities according to the laws of China, and citizens of the United States who may commit any crime in China shall be subject to be tried and punished only by the Consul or other public functionary of the United States thereto authorised according to the laws of the United States; and in order to secure the prevention of all controversy and disaffection, justice shall be equitably and impartially administered on both sides."

Under the "most favoured nation" clause in the treaties all Western countries signed with China, the rights obtained by any one country could automatically be claimed by all the others. Extraterritoriality included.

Extrality was only relinquished by the Western powers in 1943.

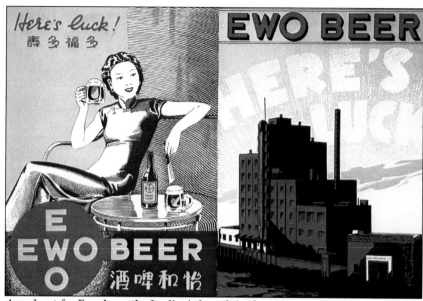

An advert for Ewo beer, the Jardine's brand, in the 1920s

Ship's Laundry

Text of a flyer handed out to sailors at the Shanghai Pier by a laundryman in the 1930s:

Dear Sir,
Would you please give me authorization for can get pickup your ship's laundry at quay. I will perform surly and speedy as showed in price list and serve free of charge (no pay) for Captain's, Exact officer's, and other officer's and Chief's would be served at half price. Relating to your ship's secret we would be blind, no ear and shut the mouth.
Your faithful servant.

The Jews in Old Shanghai

There was a large and varied Jewish community in Old Shanghai. They were some of the richest people in the city, and built many of the grandest structures, including the Cathay Hotel on the Bund, the creation of Victor Sassoon, an Armenian Jew and horse-racing fan .

Most of the long-term Jewish families were Sephardi, as opposed to be Ashkenazi Jewish refugees who came later, mostly escaping Nazism in Europe in the 1930s.

The Jews lived all over town, until in 1943, when the Japanese sent "stateless persons" to live in a "restricted area" in the Hongkou District to the northeast of the Bund, across Suzhou Creek. It was never referred to as a Jewish ghetto, but that is what it was in fact.

There were at least seven synagogues, and many Jewish hospitals and schools, most of which have been completely or partially demolished. A selection:

Ohel Rachel: 500 Shaanxi Bei Lu. Founded by Sir Jacob Sassoon, father of Victor, in his wife's memory, consecrated in 1920.

Ohel Moishe: 62 Chang Yang Lu, Hongkou. The original synagogue was founded in 1907 and moved to this site in 1927. It was for Orthodox Russian and German Jews and the headquarters of the Zionist youth organization Brith Trumpeldor (Betar). New Synagogue: 102 Xiang Yang Nan Lu. Built and consecrated in 1941. Services continued until 1956.

The Shanghai Jewish School: 500 Shaanxi Bei Lu. First founded in 1900 by D.E.J. Abraham on the grounds of Sheerith Israel, the new school was founded in 1932 by Horace Kadoorie on the grounds of Ohel Rachel.

The Shanghai Jewish Hospital: on Fenyang Lu. It was originally B'nai Brith Polyclinic, founded in 1934, and adopted the new name in 1942.

The Jewish Club on Fenyang Lu was founded by Russian Jews mainly for music performances. It is well preserved and is now occupied by the Shanghai Conservatory of Music. The Jewish Recreational Club (JRC), founded in 1912, was at 35 Mulmein Road (now Mao Ming Bei Lu).

There were four main Jewish cemeteries, but all have been demolished.

GOLDEN STATE BUTTER
SUPREME QUALITY FOR TABLE USE

½ lb. Healthful
1 lb. Sanitary
2 lb. Economical

RICH IN FOOD VALUE
Golden State 5-lb. Loaf American Cheese
The finest Cheese made in the U.S.A.
For Sale at all Provision Dealers
FU CHUNG CORPORATION, Sales Agents N. China

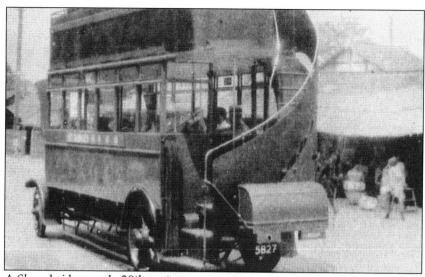

A Shanghai bus, early 20th century

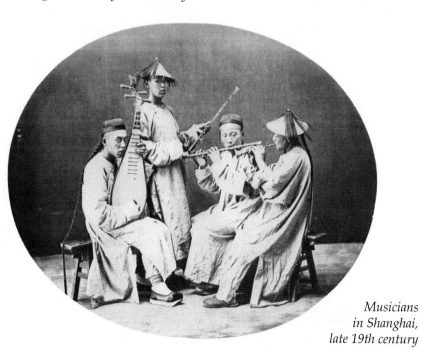

*Musicians
in Shanghai,
late 19th century*

65

The Fly Menace in Shanghai

From the China Journal, *October 1937*

By R.C. Robertson, M.D., D.P.H., and Stephen M.K. Hu, M.S., SC.D

WITH THOUSANDS of refugees massed in our city and cholera raging in our midst, Shanghailanders have gone fly-conscious these hectic days. The congested conditions incidental to hostilities around our city have resulted in a bigger crop of flies this summer and autumn than ever.

To satisfy the many enquiries concerning the present fly menace, we are making an attempt here to summarize for our local public the gist of the situation. There is a vast literature on flies: scientific works, health bulletins and pamphlets of a public health nature abound. We have here attempted to give in concise form for the general reader the main facts regarding the subject with special reference to the situation in war stricken Shanghai. We have made free use of a number of books and recommend for more detailed and technical information the works mentioned in the list of appended references. We also refer the reader to pamphlets issued by the Municipal authorities in Shanghai as well as those of the National Health Administration of Nanking.

It has been only in comparatively recent times that the facts have been fully established and the importance of the ro1e played by flies in the transmission of disease been realised.

Within the memory of the fathers of the present generation the fly was classed without question among the friends of man. A poetic enthusiast of the past actually perpetrated the line, "A dipterous angel dancing light attendance upon Hygeia."...

Shanghai is having plenty of its share of the "infinite torment of flies" at the moment. We have every reason to believe that the cholera epidemic, which has taken a considerable toll of the city's population and has been one of our chief epidemiological problems in the first months of the war, has been largely fly borne. No doubt some of the first cases were due to drinking polluted water, but case to case infection has been due to flies and the city's congestion with war refugees.

Most of the organised refugee camps have been supplied with Shanghai Water Works water, which is above suspicion, yet a certain proportion of cholera cases have occurred among refugees situated in buildings where there has been an inevitable break down in sanitary conditions. During the hostilities there has been an immense amount of decaying animal matter of the nature of human and animal corpses lying exposed without burial. This has caused an abnormal fly situation.

It would seem appropriate here to describe briefly some of Shanghai's flies, since they undoubtedly play an important role in the causation of what we locally term summer diseases,

namely, cholera, typhoid fever and dysentery. The various flies must have been observed by almost every Shanghai resident armed with a swatter during these critical days. Our natural petulance at war conditions and aerial bombing has taken a common expression in animosity against our insect aerial foes. The flies enumerated in this paper are not difficult to collect, and at the moment any interested and vindictive Shanghai resident should be able to complete the collection on a Sunday afternoon without going far afield.

The fly has no friends; it has many enemies. Its eggs are frequently eaten by fowls. The poultry which stalk about the farmyard feed gladly on flymaggots. It would be very disappointing for the parent fly to realise, if it could, that its offspring, instead of spreading disease among human beings, had merely become food for fowls. It would be an ambition blunted in its realisation.

The ideal method of fighting flies is, of course, to destroy the eggs and maggots. But this is not so easy, as the opportunities for flies to breed are so numerous, especially in a metropolis such as this, in China, where waste material in the form of decaying animal and vegetable matter appears to be an invariable accompaniment of life.

One must do what one can in protecting oneself against those flies that have happened to escape destruction from anti-maggot measures. Where the elimination of the pest is practically impossible, the first thing to be considered are methods of protecting food and drink from contamination.

The most direct of these methods is the thorough screening of doors and windows to prevent the entrance of flies. But they get in, one way or another, so we are faced with the problem of those that manage somehow to gain admittance.

Indulging in the indoor sport of swatting flies may give some satisfaction, but we must take the precaution of not landing them on our food while we are at it. The slogan, "Swat that fly," has been taken too literally in some places. Besides, the advocating of "fly swatting" on a big scale only serves to attract the attention away from the real issue, namely, the control of breeding places. Interest should be won over to the side of civic cleanliness, and the slogan will have to be changed from "swat that fly" to "swat that manure pile."

Sticky fly papers may be more of a nuisance than anything else, but, if properly handled, serve a good purpose. House flies are very fond of gathering on a string or strip of paper hanging from the ceiling. This may be taken advantage of in a very effective manner by suspending narrow strips of sticky fly paper from the ceiling.

Finally we must admit that all methods of killing the flying insect are unsatisfactory. When all are convinced that the fly is a creature of disgusting and dangerous habits, no more to be tolerated inside our dwellings and provision shops or upon our meal tables than a plague-stricken rat, then we may expect the kind of cooperation with the health authorities which will render community action effective in suppressing this pest at its very sources.

A Long and Profitable Innings

Arthur Ransome writing in the Manchester Guardian in 1927. He was right, but premature by a quarter of a century.

It seems to be generally recognized by all but a few die-hards in Shanghai that the time has come when a change in the relations between British and Chinese is inevitable. It is, of course, hard not to sympathize with those Englishmen who have grown accustomed to the established ways and now look forward rather gloomily to life in a Chinese world very unlike the old. It is easy to understand the pained surprise of businessmen who have for years been able to count on Chinese labour at a stable wage, low in comparison with wages at home, at finding themselves face to face with trade unions which have yet to learn the difference between extravagant and economically justifiable demands. At the same time, one can but feel that they have had a long and profitable innings ... They have been jerked in a few months from the Victorian era to the present day.

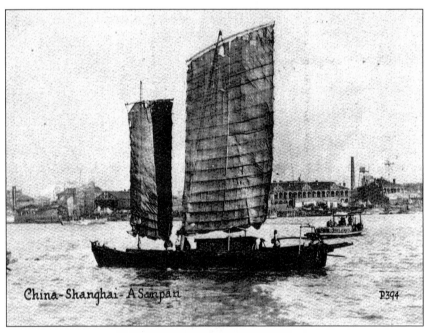

China-Shanghai- A Sampan P.394

A sailing junk on the Huangpu with the Bund behind, around 1900

The 1915 Census of Foreign Residents of the Shanghai Settlements

International	French Settlement	Nationality Concession	Total
Japanese	7169	218	7397
British	4822	699	5521
Portuguese	1323	29	1352
American	1307	141	1448
German	1155	270	1425
Russian	361	41	402
French	244	364	608
Spanish	181	4	185
Italian	114	55	169
Danish	145	33	178
Austro-Hungarian	123	27	150
Turkish	108	2	110
Norwegian	82	27	109
Swiss	79	35	114
Swedish	73	10	83
Dutch	55	23	78
Belgian	18	32	50
Greek	41	7	48
Persian	39		39
Korean	20		20
Rumanian	16	2	18
Egyptian	8	8	
Armenian	5	5	
Latin-American	5	4	9
Montenegrin	2	2	
Bulgarian	2	2	
Indian	1009	18	1027
Sundries	13	364	377
Total	**18519**	**2405**	**20924**

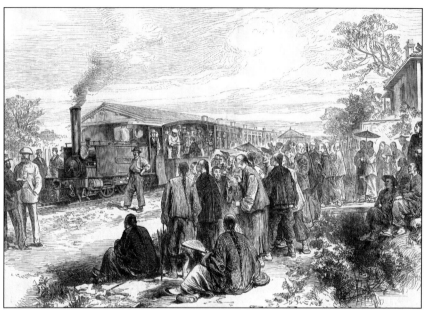

Opening of the first railway in China from Shanghai to Woosung Port.
(Illustration from The Illustrated London News, *September 2, 1876).*

The Railway

The railway first arrived in Shanghai in 1876, but left again almost immediately.

The Chinese government was so fearful of this new mode of transport that they bought up the line, dismantled the entire system and dumped all the rails and rolling stock on a beach on the island of Taiwan. It was another 20 years before trains ran again in Shanghai.

When General Gordon was about to capture Suzhou from the Taiping rebels in 1864, English and American firms petitioned Chinese officials to build a railway linking Shanghai with that city. The officials refused the request saying that "railways would only be beneficial to China when undertaken by the Chinese themselves and conducted under their own management".

In 1865, businessmen in Shanghai gained permission to reconstruct a road linking Shanghai with Woosung, the port at the entrance to the Huangpu River, about 12 miles away. They used the company as a cover to begin construction of a railway, but it was abandoned

because of high costs until 1872 when an engine and cars were ordered from England. The rails arrived in Shanghai in late 1875, and were laid along the route. The first five-mile stretch of track to Kiangwan, opened for traffic on June 30, 1876.

The train made six trips a day along the track, and was always crowded. In July, receipts averaged around $50 daily and operations were considered to be "highly satisfactory" until on August 3, 1876, a man walking on the line was killed "under circumstances which suggested, either extremely dense stupidity or a malicious intention to commit suicide, and thereby create a prejudice against railways", as one English writer put it.

The Chinese people became hostile, and the British authorities ordered the train service to stop. The Chinese government announced it wished to purchase the line, and Wade told the agents Jardine Matheson's that as the railway had been built without official approval and could not be defended by the British government, it would be best to sell. Jardine's agreed, as long as the price covered all the costs. In October, 1877, a sum of 285,000 taels was paid for the land, rolling stock, and rails. The last train which ran was pulled by the engine "Victory" followed by the "Celestial Empire." The rails were torn up and shipped with the rolling stock to Taiwan, where they were left to rust on the beach.

But Jardine's didn't give up on the prospect of building railways across China, and neither did other foreign firms. A short (seven-mile) line was built at the Kaiping coal mine and went into service in 1881, which was encouraging, and in 1887, Jardine's pushed the offer of a loan to extend the line. This was approved by the Chinese Emperor, and the Kaiping Railway Company was renamed as the China Railway Company. From that eventually grew the entire Chinese rail system.

Waiting in Nanking station for the arrival of the first train from Shanghai in 1908. C.E. Anton of Jardines (fifth from left) stands with Chinese officials and railwaymen.

Shanghai Symphony

From All About Shanghai, *a 1934 guide to the city*

COSMOPOLITAN Shanghai, city of amazing paradoxes and fantastic contrasts; Shanghai the beautiful, bawdy, and gaudy, contradiction of manners and morals; a vast brilliantly-hued cycloramic, panoramic mural of the best and the worst of Orient and Occident.

Shanghai, with its modern skyscrapers, the highest buildings in the world outside of the Americas, and its straw huts shoulder high.

Modern department stores that pulse with London, Paris, and New York; native emporiums with lacquered ducks and salt eggs, and precious silks and jades, and lingerie and silver, with amazing bursts of advertising colour and more amazing bursts from advertising musicians, compensating with gusto for lack of harmony and rhythm.

Modern motors throbbing with the power of eighty horses march abreast with tattered one-man power rickshaws; velveted limousines with silk-clad Chinese multi-millionaires surrounded by Chinese and Russian bodyguards bristling with automatics for protection against the constant menace of kidnapping (foreigners are not molested); Chinese gentlemen in trousers; Chinese gentlemen in satin skirts.

Shanghai the bizarre, cinematographic presentation of humanity, its vices and virtues; the City of Blazing Night; cabarets; Russian and Chinese and Japanese complaisant "dance hostesses"; city of missions and hospitals and brothels.

Men of title and internationally notorious fugitives tip cocktails in jovial camaraderie; Colonels' Ladies and Judy O'Gradys promenade in peacock alley; social celebrities and convivial cocottes; ladies who work; ladies who shirk: ladies who live to love; ladies who love to live. Behold! "The longest bar in the world!" The shortest street in the world with a blatant cacophony of carnality from a score of dance-halls; scarlet women laughing without mirth; virgins in search of life; suicides; marriages; births; carols of vested choirs; cathedral chimes; Communists plotting; Nationalism in the saddle; war in Manchuria!; it's a great old town, and how we hate it and love it!

Vital, vibrant, vivacious; strident, turbulent, glowing – Shanghai is the Big Parade of Life of every colour, race, tempo; the bitter end of the long trail for many wastrel souls; the dawn after the dark for others.

Shanghai the incomparable!
So this is Shanghai!
Let's take a look at it!

Cleanliness in the Streets

Letters to the editor of the North-China Daily News, *December 1914*

SIR, Most of us who have been in China for a year or two are fully aware that the Chinese expectorate in the streets rather more freely than we do without considering it anything extraordinary ... I believe that, were notices exhibited prohibiting expectoration on our pavements, the beneficial effect would soon be noticeable, and that where not so – e.g. in the case of the insolent class (far more numerous than you would appear to think) – a good box on the ears from a policeman now and then would work wonders.

Signed Pedestrian

SIR, Some of your correspondents advocate the "boxing of the ears" as a sound remedy against this alleged evil ... I would suggest that those foreigners who desire to teach my fellow citizens good manners should first try boxing the ears of their own nationals who smoke bad tobacco in the tramcars, and blow the offensive smoke into their mothers' and sisters' faces. When this turns out successful, I am perfectly confident that my fellow citizens would not object to being taught Western manners. Otherwise it would certainly not be fair to box a coolie's ears for an offence he commits unwittingly through lack of education, while the educated "white man" commits the offences with impunity.

Signed Wong Ming-Kung

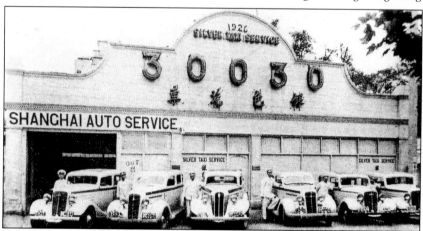

Silver taxis were famous in 1930s Shanghai. Ralph Shaw says in Sin City *they could be rented with a girl in the back for a trip around town.*

Tea waiting to be exported at Shanghai Port, with British tea inspectors.

Shanghai Waif

from China Coast Ballads *by Shamus A'Rabbit, 1938*

"No mamma
No papa
No whisky soda
No chow."

Pierced the air
And pierced the din
Of the Shanghai
crowd
On road Nankin!

"No mamma
No papa
No brother
No sister."

While nimble fingers
And nimble hand
Juggled four knives
Near the chow-chow
stand.

"No mamma
No papa
No dolla
No chow."

Came through the
crowd
To the passers by

From the Chinese girl
With a naughty eye.
"No mamma
No paper
No whisky soda
No chow."

Jostled by rickshaws
She cursed them
aloud
And juggled four
knives
Amusing the crowd.

"No mamma
No papa
No brother
No sister

Then a big Sikh
Policeman's
Baton
Just missed her.

"No mamma
No papa
No dolla
No chow."

The knives went like magic
Despite the mock bow.
Juggling four chop sticks
She wrinkled her brow.

"No mamma
No papa
No whiskey soda
No chow."

She slipped across
A sailor's path.
A sailor drunk
Who swore his wrath.

"No mamma
No papa
No whiskey soda
No chow."

"Get out of my way
Or I'll kick your pants."
With grimace she said.
"No have got pants."

"No mamma
No papa
No whiskey soda
No chow."
Ten cents please!

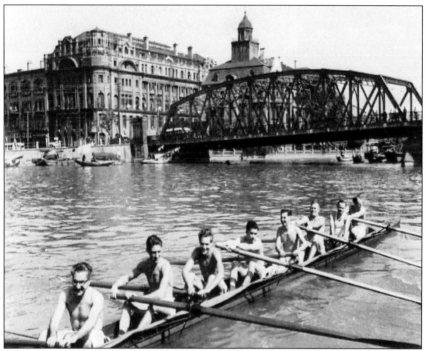

A foreign rowing crew on Soochow Creeek, perhaps mid-1930s

The Siren-note

An excerpt from Andre Malraux's Man's Estate, *set in 1926*

Slowly a long siren-note swelled until it filled the wind which wafted across the faint hum coming from the besieged city, almost silent now, and the hooting of the picket-boats as they returned to the men-of-war. Wafted it across, and bore it away past the wretched electric lamps which glimmered down the side streets and the alleys which engulfed them: all around them crumbling walls stood out from the waste of shadow, laid bare in all their blotchy nakedness by that merciless un-wavering light, which seemed unearthly in its unrelieved drabness. Those walls hid half a million men: hands from the spinning-mills, men who work sixteen hours a day from early childhood, ulcerous, twisted, famine-stricken. The coverings which protected the bulbs lost their clear outline, and in a few minutes rain, rain as it only falls in China, raging, slashing down, took possession of the town.

Opium

OPIUM WAS at the centre of one of the great controversies of the nineteenth century and the foundation of the fortunes of Shanghai and other foreign settlements along the China Coast.

There was hypocrisy on the part of both Britain and China over the issue, and both shared the blame. Chinese Imperial officials railed against the British for forcing the bitter, yellowish-brown narcotic onto the Chinese people, but took kickbacks from the traders and smoked the drug themselves. The British justified the trade on the grounds that opium was the only commodity China was willing to buy to balance Britain's purchases of tea and silk.

Opium was a huge and lucrative

"Edicts are still issued against the use of opium. They are drawn up by Chinese philanthropists over a quiet pipe of opium, signed by opium-smoking officials, whose revenues are derived from the poppy, and posted near fields of poppy by the opium-smoking magistrates who own them."

Australian journalist
George E. Morrison in 1895

trade for much of the nineteenth century, dominated by the British: poppy farms and opium processing plants in India, fast clipper ships to bring the product to the China market, and heavily-guarded opium storage hulks moored off the coast where local smugglers could pick

up supplies. By 1890, it is estimated that about 10 percent of China's total population were opium smokers.

It was a well known and widely used drug in the West too, largely as a pain-reliever, and as a remedy for diarrhea. But in China, it was not being promoted by the British for medicinal purposes. The Chinese knew what damage the drug was doing, and in 1839, China's opium commissioner Lin Zexu seized and destroyed 20,000 chests of opium from British traders in the southern city of Canton. The British demanded compensation and the opening of five ports along the China coast — at that time all foreigners in China were confined to Canton. Thus started the first Opium War, which ended inevitably in complete defeat for the Chinese at the hands of the much superior British military forces. Shanghai was declared open to foreign trade in November, 1843.

Opium usage boomed. It spread right through Chinese society from the Imperial Palace to lowly labourers. It was a means of escape from reality — as understandable for the ruling Manchus as their empire slowly collapsed around them, as for the poor coolies trying to forget their nightmarish lives.

In Shanghai, huge fortunes were made, financing profligate lifestyles and magnificent castles back home in Scotland. In 1870, opium still

Huang Jinrong, known as Pockmarked Huang, was police chief of Shanghai's French Concession and also the man who controlled the flow of opium through the city in the 1920s and 30s.

accounted for 43 percent of China's total imports, with cotton goods a distant second at 28 percent.

But finally, the days of quick opium profits drew to a close. Chinese domestic production soared and by 1870, the trading house of Jardines had basically pulled out of the trade and was instead pouring its drug-based profits into new ventures such as banking, mining and railways. The anti-opium lobby, meanwhile, was gaining ground and the Shanghai Municipal Council

stopped issuing licences for opium dens in 1907. The last legal opium shop in the city closed in 1917.

This in no way stopped the opium trade, of course: it just pushed it into the hands of the underworld. Opium in Shanghai in the 1920s and 1930s was controlled by 'Pockmarked' Huang Jinrong, the senior Chinese officer in the French gendarmerie, and 'Big Ears' Du Yuesheng, head of the Green Gang triad. Du was the city's top gangster and, as Shanghai's Who's Who of 1933 described him, a 'well-known public welfare worker'.

Opium was available to Europeans in the old Shanghai who wished to partake, and some did so, although it was overwhelmingly a Chinese vice.

The smoker lay in a gloomy opium den cubicle, with the smoking apparatus laid out on a low table to one side. In establishments for the well-to-do, comely wenches tended to the opium pipes and to the sensual needs of customers. The dark, sticky raw opium was twisted around a pin and cooked over a lamp until it hardened amidst much bubbling and crackling. It was then placed in the bowl of the pipe, which was then turned towards the flame. A pipe was completed in just a couple of minutes. Aficionados would have half a dozen or more pipes at one go, the pupils of their eyes shrinking to needle-points in

the process. The smoking technique required some practice. "Imagine that you are a child that sucks its mother's breast," was the advice one smoker was given. It was important to draw continuously, allowing the rich flavours and vegetable smells to seep through your being.

The effect on the mind, according to tradition, was deep psychedelic dreams. But the reality was more a seductive stupor of calm and feelings of well-being.

Opium was finally driven from Shanghai after 1949 when the Communists marched in, closed down the opium dens, and forced addicts into rehabilitation.

But it returned in the 1990s, this time in the form of heroin, and this time as an all-Chinese business. The British and Indian drug traders were long gone.

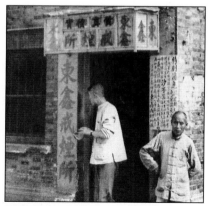

This opium den disguises itself as an addiction treatment center. Early 1900s.

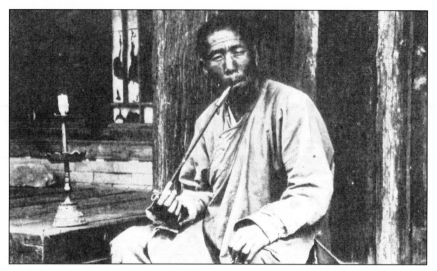

Viscount Palmerston's instructions to Sir Henry Pottinger with regard to opium, on his departure for China on 31st May, 1841:

It is of great importance, with a view to the maintenance of a permanent good understanding between the two countries, that the Chinese government should place the opium trade upon some regular and legalised footing. Experience has shown that it is entirely beyond the power of the Chinese Government to prevent the introduction of opium into China; and many reasons render it impossible that the British Government can give the Chinese Government any effectual aid towards the accomplishment of that purpose. But while the opium trade is forbidden by law it must inevitably be carried on by fraud and violence; and hence must arise frequent conflicts and collisions between the Chinese preventive service and the parties who are engaged in carrying on the opium trade. These parties are generally British subjects; and it is impossible to suppose that this private war can be carried on between British opium smugglers and the Chinese authorities, without events happening which must tend to put in jeopardy the good understanding between the Chinese and British Governments. H.M. Government makes no demand in this matter; for they have no right to do so. The Chinese Government is fully entitled to prohibit the importation of opium, if it pleases; and British subjects who engage in a contraband trade must take the consequences of doing so. But it is desirable that you should avail yourself of every favourable opportunity to strongly impress upon the Chinese Plenipotentiary, and through him the Chinese Government, how much it would be for the interest of the Chinese Government itself to alter the law of China on this matter, and to legalise, by a regular duty, a trade which they cannot prevent.

Natural Appetite

"I learned from Chinese sources that in several of the large cities of the province eighty per cent. of the men and forty per cent. of the women are opium smokers; but this must not be understood to mean that they are opium 'wrecks,' for there is a vast amount of 'moderate' opium smoking in China. In my boat on the Yangtze fourteen out of sixteen very poor trackers smoked opium, and mong my char and baggage coolies it was rare to find one who did not smoke, and who did not collapse about the same hour daily with the so-called unbearable craving."

A comment by Isabella Bird in The Yangtze Valley and Beyond

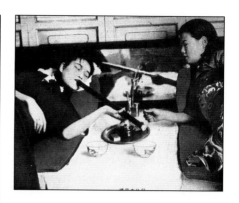

"Opium smoking is the staidest form of indulgence, the most sedentary and least uncivilised of all the vices."

British writer Peter Quennell, who visited Shanghai in 1931

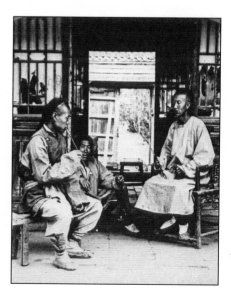

NORTHAMPTONSHIRE
Evening Telegraph

Established 1897 MONDAY, APRIL 25, 1949 Price Three Halfpence

MOVE TO SAVE SHANGHAI

Realises Ambition

Businessmen Reported in Touch With Reds

A MOVE is under way to save Shanghai from heavy war damage by handing the city over peacefully to the advancing Communists, according to a source close to high China Government officials, to-day.

Amethyst Men Get Some Rest
"No Wounded on Board"

LATEST signals from the shell-battered Amethyst, stranded in the Yangtse, stated that she had a quiet night and that the crew were in good heart.

Signals from the Amethyst also stated that two wounded —a boy and a stoker—who landed from the ship, have not yet been located.

It was thought that they may be in Chenkiang, south of Chinkiang, but efforts to communicate with them were unsuccessful.

The 96 odd men remaining on the Amethyst are testing and getting their strength

Communist troops were early to-day reported to have entered Kunshan, on the railway 35 miles west of Shanghai. Another report placed them at 22 miles from the city.

The British Consul-General issued a notice to the British community saying that for those who wanted to leave the city emergency accommodation could be provided at Hongkong.

The notice added that Sir Ralph Stevenson, British Ambassador, did not favour a general evacuation of the 4,000 Britons in Shanghai. Comparatively few applications had been received by midday.

Pollitt: Six Men Fined

SIX men were fined at Pig month to-day on charges of assaulting the police and obstructing them in the execution of their duty.

More than 300,000 Government troops concentrated for the defence of Shanghai to-day after retreat in torrential rain.

A Government military spokesman said that Shanghai's defence, manned by 15 armies, who withdrew "in perfect order from positions to the east, were strong."

Thousands of refugees to-

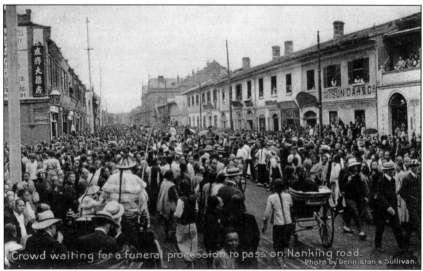

JACQUELINE ("Jackie") Hylton, 17-year-old daughter of Jack Hylton, the well-known impresario, is now the proud owner of a racehorse, "Limeboy," seen here with "Jackie" in the saddle,

during a workout near the Epsom stable where he is housed. She hopes, eventually, to own more racehorses and to take up training seriously. Her father recently acquired a share in two horses.

MARCH EXPORTS

Note on Dead Woman's Coat

MAN WAS HANGED BEHIND DOOR

A POLICE Sergeant who broke into a Kensington, London, flat and found a woman strangled on the floor and a man's body hanging behind a door said at a Hammersmith inquest to-day that on the woman's coat was a note saying, "God bless you, darling. You cannot fool any more men as you thought you were fooling me."

The resumed inquest was on Ellen Leonia Barton (35) and Reginald James Collins (50), motor mechanic, who shared a flat at Ladbroke Court, Kensington.

They were found dead there on April 13th.

The jury returned a verdict that the woman was a victim of manslaughter, and that Collins committing suicide whilst the balance of his mind was disturbed.

Sergeant Meskin, who found the note on the woman's chest, said that in the flat were other letters written by Collins after her death.

The Coroner (Dr. C. W. Robinson) read an extract from the letters, which said: "What has led up to this was when she made arrangements to meet another man when I was with her.

"As we were going down the area steps she said: 'You wait

(See Back Page)

Farmer Shoots Two Dogs
EWE FOUND MAIMED

TWO dogs, caught in the act of worrying an ewe at Rushden this morning, were shot dead by a farmer. He went out on a hunting expedition after he had seen them chasing calves.

"There was some meat on the ground torn out of the sheep," said the farmer, Mr. J. H. West, of Manor Farm.

"They were pulling her apart. There was blood all over her. I don't think she'll live. I expect I shall have to kill her, but it will mean that the lambs are without a mother.

Mr. West, who had not spotted the rest of his 300-odd sheep, who were standing terrified against a gate, said

Northamptonshire Evening Telegraph. Monday, April 25, 1949

Crowd waiting for a funeral procession to pass on Nanking road.
Photo by Denniston & Sullivan.

Postcard, early 1900s

The Black Cat

An excerpt from Andre Malraux's Man's Estate, *set in 1926*

The taxi stopped in front of a minute garden, the entrance to which was lit up by the words: Black Cat. As he went past the cloakroom, Kyo looked at the time: two o'clock. 'It's a good thing any kind of clothes will do here.' Beneath his dark grey sports coat, of fluffy wool, he was wearing a sweater. The jazz was inconceivably irritating. It had been going on since five o'clock, proffering not so much cheerfulness as a frenzied intoxication to which couples gave themselves up a little doubtfully. Suddenly it stopped, and the crowd broke up. The patrons of the establishment collected at the far end of the room, and the dancing-partners sat round the sides. Chinese women sheathed in worked silk, Russians and half-castes; one ticket for each dance, or each conversation. An old man who might almost have been an English clergyman remained standing in the middle of the floor, completely bewildered, flapping his arms up and down like a penguin. For the first time in his life, at the age of fifty-two, he had failed to come home one night, and his dread of his wife was such that he had never since dared to return. For eight months now he had been spending his nights in the night-clubs, unable to get any washing done, and going to the Chinese shirt-makers to change his underwear, between two screens. Businessmen faced with bankruptcy proceedings, dancing-girls and harlots, all who felt themselves in danger – in fact almost everybody – kept their eyes fixed on that apparition, as if it had some strange power to save them from being engulfed in the abyss. At dawn they would go to bed, in a state of utter exhaustion – just when the executioner would be on his way through the Chinese quarter. That hour reminded one inevitably of the severed heads lying in the cages, lying there with their hair soaked by the rain, before even it was quite light.

The Kennel

From the China Journal, May 1936

The China Kennel Club's Annual Dog Show: The annual Dog Show of the China Kennel Club is being held in Shanghai this year at the Race Club on May 17, when it is expected to see an unusually fine turnout of Shanghai's canine aristocracy. Membership in the China Kennel Club has now reached the figure of 246, an increase of eighty-two since last year, while nearly five hundred dogs have now been registered by the Club.

Municipal Regulations Announced: The attention of dog owners in the International Settlement of Shanghai is called to a notification published in the Municipal Gazette regarding the regulations governing the licensing and muzzling of dogs. It points out that "dogs when on the streets or other place of public resort must be effectively muzzled, but in such a manner as will admit of its breathing and drinking." We would like to insert the word "freely" after "breathing," as we have noticed many cases in which the muzzles have been outrageously cruel, preventing the wretched dogs from opening their mouths sufficiently wide to breath freely, especially on warm days. Dogs found in the streets or on the outlying roads without muzzles are liable to be shot, if they cannot be captured. If caught they will be impounded for a minimum of three days, and their owners, if and when located, prosecuted. Dog owners are requested to present their application for licenses at the Revenue Office of the Municipal Council or at Bubbling Well, Gordon Road or Yangtzepoo Police Stations, together with $5 for each dog.

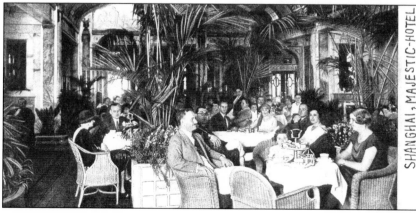

SHANGHAI, MAJESTIC-HOTEL

Toleration of Eccentricities

An excerpt from Vicki Baum's novel, Shanghai 1937

At about midnight they were in Wing On's establishment. A house of Chinese entertainment, with jugglers, conjurers and dancing girls, and many little stages on which coarse farces were played with much chirping and screaming to the companiment of wooden instruments and varied and powerful stenches. The Chinese stood crowded in front of it, bursting with laughter.

Paper flowers, lanterns, banners, letters of red and gold and an air so thick it exceeded anything the Russells had hitherto endured. They recovered in a smart little night club in the Settlement where the Chinese, Korean and Japanese girls twirled their partners on a lighted floor of glass. At one o'clock they were in a shabby place not far from the Bund where French sailors danced with Russian girls and Japanese imitations of American drinks were gulped down. At two they were leaving a Chinese hotel where the native crooks took their pleasure, where yellow-skinned gangsters, blackmailers and leaders of thieving gangs with their exceedingly beautiful girls danced the rumba to a Philippine orchestra. Somewhat later they were walking down Foochow Road, Bobbie maintaining himself in a perpendicular position between them with extraordinary ingenuity.

Bobbie's condition had its well-marked ups and downs, mountains and valleys of exhilaration and melancholy. Now he had become obstinate and refused to go home. Inebriation produced an urge to self-annihilation in him: he wanted to press on deeper and deeper into the dirt and corruption to which whole quarters of this city were given up.

"Your wife's tired, Bobbie," Frank said at intervals.

"She can go to the devil," Bobbie replied each time.

Frank looked at Helen; she smiled gaily at him, unapproachable and unmoved. Her hair was smooth and shining under the silk of her hat, the maize-yellow dress was without a crease, and her skin looked perfectly fresh. Like fruit, Frank Taylor thought thirstily.

On they went — to the White Chrysanthemums, a Japanese place far out in Chapei, to the Dragon's Cave, where there was only an electrical piano, and to the Flower Boat, a Chinese brothel, where landscapes of the Bavarian Alps hung on the walls, where children turned cartwheels, where there was not a girl over sixteen and not a man was sober.

Towards three o'clock in the morning they rose again from the depths and arrived at Delmonico's, where at this time of day the whole

of Shanghai went for scrambled eggs or onion soup. Every shade of race, elegance and intoxication was to be met there.

It was at Delmonico's that Bobbie began to storm. At first he sat mute for some time, staring into vacancy over his soup with a fixed smile. "Bobbie," Helen said, touching his sleeve. Suddenly he got up and walked stiffly and in a beeline to a distant table and said to a lean, gray-haired Chinese in a dress coat: "I forbid you to stare at my wife, you Chinese swine."

The Chinese pretended not to have heard and went on talking with the Frenchman at his table. Everybody in the place knew the gentleman in evening dress: he was a man of great importance in the government.

"You swine of a Chinaman!" Bobbie roared so loudly that his voice broke. People turned to look at him. Their faces showed neither astonishment nor annoyance, only that toleration of eccentricities which is second nature in Shanghai.

"Conduct the gentleman into the fresh air, he seems to be suffering," the Chinese in the dress coat said to a waiter, also in dress clothes. The maitre d'hotel, a pale, swarthy, handsome Portuguese, took hold of Bobbie with a jujitsu grip and lugged him outside. The Chinese turned back with a smile to his friends. "How ashamed he will be when he is sober and remembers his behavior," he said with a tolerance that was contempt. "The climate of Shanghai does not always suit the English race very well."

The head of the Chinese revolution Sun Yat-sen (front left) at a party given for him in Shanghai by Silas Hardoon (front right) on April 6, 1912, five months after the fall of the Manchu empire.

Stealing Time

An excerpt from The Yangtze Valley and Beyond, *by Isabella Bird*

Shanghai in every way makes good her claim to be metropolitan as well as cosmopolitan, and, in spite of dark shadows, is a splendid example of what British energy, wealth, and organising power can accomplish.

To us the name Shanghai means alone the superb foreign settlement, with all the accessories of western luxury and civilisation, lying grandly for a mile and a half along the Huang-pu, the centre of Far Eastern commerce and gaiety, the "Charing Cross" of the Pacific — London on the Yellow Sea.

But there was a Shanghai before Shanghai — a Shanghai which still exists, increases, and flourishes — a busy and unsavoury trading city, which leads its own life according to Chinese methods as independently as though no foreign settlement existed; and long before Mr. Pigou, of the H.E.I.C., in 1756, drew up his memorandum, suggesting Shanghai as a desirable place for trade, Chinese intelligence had hit upon the same idea, and the port was a great resort of Chinese shipping, cargoes being discharged there and dispersed over the interior by the Yangtze and the Grand Canal. Yet it never rose higher than the rank of a third- rate city.

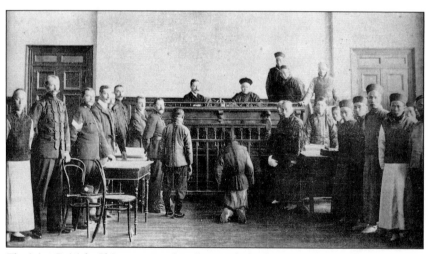

The joint British-Chinese court, hearing a criminal case against a Chinese person accused of committing a crime in the Internal Setllement

Sidewalk Business

In Shanghai High Lights, Low Lights, Tael Lights *by Maurine Karns & Pat Patterson.*

Even in the coldest weather, sidewalk business is popular in Shanghai. This is probably because the Chinese will stop to watch anything. If one bends over to fix a shoe lace, he will straighten up to find himself the center of a staring crowd. Street altercations gather mobs. A traffic mix-up interests everyone but the police who nonchalantly show up only after all participants exhaust their capacity for abuse.

Astor House was the first luxury hotel in Shanghai, originally constructed in 1860 and later rebuilt in the same location near Garden Bridge in 1901.

Flower Show
From China Journal, *May 1932*

Shanghai Horticultural Society's Sixtieth Show: The Shanghai Horticultural Society is holding its sixtieth Annual Spring Flower Show on May 16 and 17 at the Race Club. It is hoped that there will be an unusually large attendance to celebrate the occasion, as there is going to be a particularly attractive display, in spite of the extremely late season.

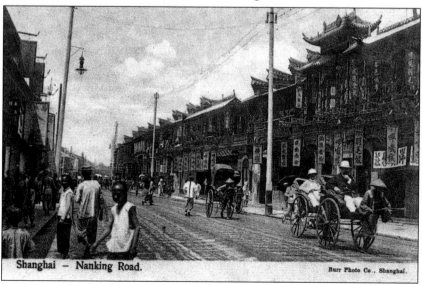

Shanghai – Nanking Road.

Burr Photo Co., Shanghai.

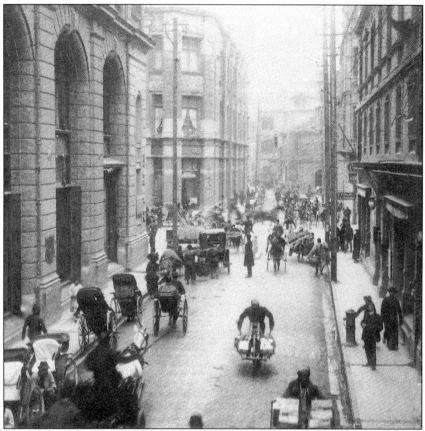

Henan Road in the early 20th century.

Me No Worry ...

Me no worry
Me no care
Me going to marry a millionaire
And if he die
Me no cry
Me going to get another guy.
*Refrain from a popular Shanghai
song in the late 1940s*

Al Capone's Armoured Car

A memoir by Russell T. Barnhart

In the winter of 1945-46, after the Japs had surrendered, I was a flag yeoman (clerk) working in the personnel section of the U.S. 7th Fleet (Admiral Thomas C. Kincaid was SOPA, or senior officer present afloat, at buoy #1) aboard a ship at buoy #12 for Commodore E. E. Duval Jr.

One day my immediate boss, a lieutenant, told me to go over to the Glen Line building on the Bund (headquarters of Rear Admiral Milton E. Miles who was SOP, or senior officer present – on land). I was supposed to help SOP set up a Shore Patrol as the U.S. Army, which had come over the Burma (Stilwell) Road, had already set up their MP unit.

As I approached the Glen Line, I saw a crowd of coolies surrounding there an armored car in the front seat of which sat a second-class boatswain's mate. Not surprisingly, being a kid from Chicago, I asked my shipmate questions for the next fifteen minutes, and this was his explanation:

The armored car was a 1925 seven-passenger sedan, custom-made for Al Capone in Chicago, who paid $20,000 for it. The boatswain's mate got out of the car and took me around this vintage vehicle like a proud salesman touting its features. The glass in all the windows, front, side, and back, was 100% bulletproof, just like the gas tank. The interior venetian blinds were made of quarter-inch thick steel, and the slits along the top were for the barrels of Thompson submachine guns. The armored car weighed seven tons, and was used by Al Capone in the 1920's and early 1930's in Chicago.

"But what is it doing here?" I asked. "What, boats, are you doing in the front seat?"

"I drive the Admiral around town. He inherited it from its former owner, the chief of police of Shanghai, who had to leave town under a cloud because he'd collaborated with the Japs during their occupation, before the 7th Fleet pulled in."

"Which Admiral is that?"

"Admiral Miles."

A public bus on a Concession street in the 1930s. Shanghai's public buses appeared after the tram. In 1922 a Chinese businessman bought two large vehicles and transformed them into buses to run the first route between Jingan Temple and Zhongshan Park.

A letter sent to a gentleman in Peking via Shanghai in 1878

94

Racing Dogs Killed by Chinese Shell

From China Journal, *September 1937*

One of the most tragic incidents in relation to animals which we have to record is the killing of forty-two valuable greyhounds belonging to the Canidrome while they were being evacuated from the breeding kennels in the Yangtzepoo area. Some 160 greyhounds had been loaded on trucks, which were proceeding toward the central district of the International Settlement south of Soochow Creek. When crossing the Hongkew Creek Bridge at noon on August 15, the leading truck was hit by a shell from Chapei, which exploded, killing the forty-two dogs, the Chinese driver of the truck and six Chinese bystanders.

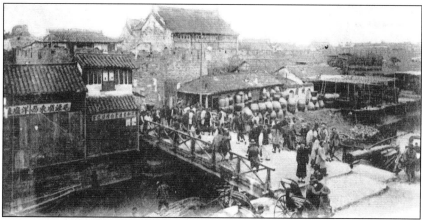

The bridge linking the old city and the French Concession. Around 1900.

The Battle of Muddy Flat

On April 4, 1854, a force of 400 British and American volunteers attacked Chinese Imperial troops who were camped near Shanghai, engaged in a stand-off with the Small Sword rebels occupying the Chinese city. Frances Wood in her book *No Dogs and Not Many Chinese,* adds:

In his account of the battle, a local resident Mr Wetmore maintained that the ground was not muddy but dry and dusty, though in crossing the small creeks that traversed the area, the troops doubtless got muddy feet. Some think that the battle was originally called the Battle of Muddy Feet and that the change in name was the result of a rather serious misprint.

The French Concession

Monsieur Montigny, the first Consul for France at Shanghai, entered into an agreement with Ling Taotai (Taotai being the title of the senior local Chinese official) on April 6th, 1849, for the establishment and government of a French Concession. In the beginning it appeared likely that the settlements would be run as one administrative unit. But the French finally decided to set up a separate municipal government. The French Consul had signed the 1854 Land Regulations, but they felt they were not bound by the regulations as they were never ratified by the French Government. So on May 13th, the Municipal Council of the Concession Francaise was formed. It differed from the English Municipal Council in that all its decisions were subject to the approval or veto of the French Consul. As most of the foreign trade of Shanghai was carried on through the British Settlement, the French Concession found it difficult to raise revenues, and depended largely on income derived from licenses to opium divans, brothels and gambling houses.

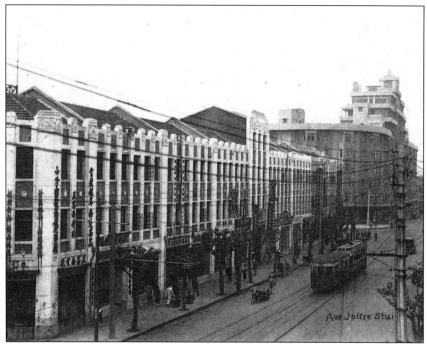

Sleepy Avenue Joffre (today's Huaihai Rd) in the French Concession.

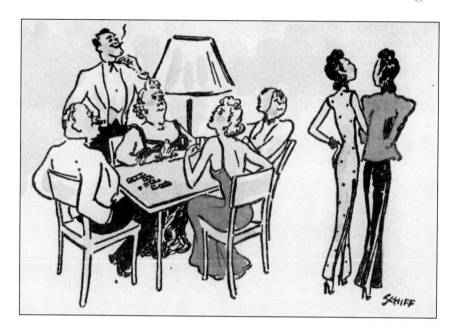

The Shanghai Businessman

An excerpt from American journalist Harry Franck's 1925 book Roving through Southern China

(He) rents as nearly an American house or apartment as he can get, near a trolleyline if he is still below the automobile scale, and settles down into the narrow rut of Western existence amid the more or less Occidental comforts ... His office is as much like the offices of his homeland as he can make it; at noon, he gathers, almost exclusively with his own fellow-countrymen, in his club, an almost exact copy of similar gatherings at home ... except that the more or less slight sense of secrecy in the matter of strong drink is replaced by an almost ostentatious publicity ... When his business day is over he is trolleyed or chauffeured home, or out to the country club, plays a round of golf, or a set of tennis, or rides an hour on horse-back ... He dines, at home, club or foreign hotel, as nearly in the homeland style as carefully instructed Chinese cooks and 'boys' can accomplish, and settles down to the home newspapers and magazines, though they are seldom less than a month old.

97

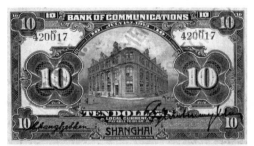

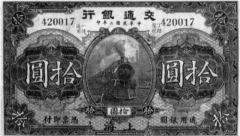

The Most Agreeable Place

Laurence Oliphant, 1856, in his book Narrative of the Elgin Mission to China and Japan

(There are people) riding or gyrating daily on the race course, as though they were being lounged. Those who prefer gossip to exercise frequent the Bund, a broad quay which extends the whole length of the Settlement, and which is crowded with Chinese porters all the morning and sprinkled with European ladies and gentlemen in the afternoon. The harmony and hospitality of Shanghai make it infinitely the most agreeable place of residence in China.

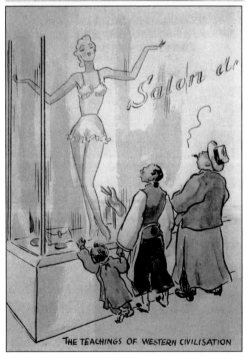

THE TEACHINGS OF WESTERN CIVILISATION

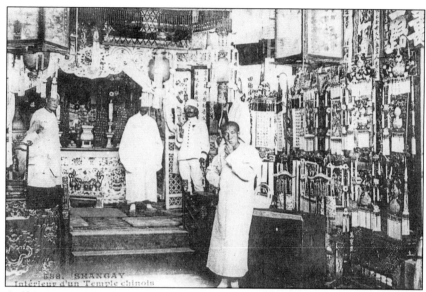

A Chinese temple around 1900.

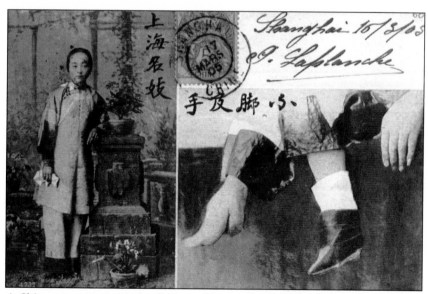

A Chinese prostitute. Notice the bound feet on the right. Early 1900s

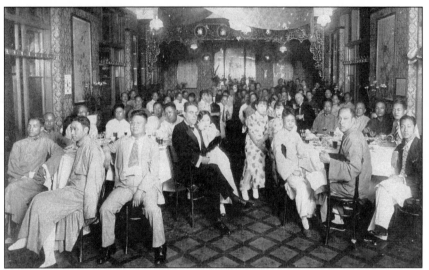

An end of year party for the managerial staff of Texaco at the Xinghua Lou (Restaurant).

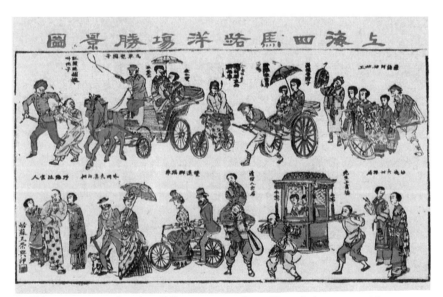

A Chinese cartoon showing different scenes from Shanghai streets, with foreigners on bicycles, an Indian policeman and a foreign carriage.

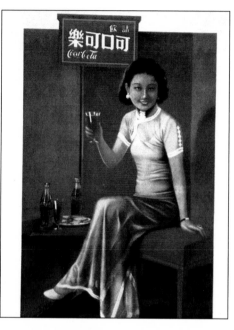

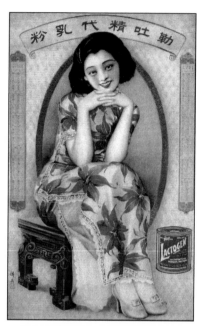

Goodbye

You Smyrna weeping London's tears.
You London racked by Smyrna's
fears.
Busy, detestable Shanghai.
Our anchor's up. Thank God.
Goodbye.

Historian
Arnold Toynbee

LAND MINES

MR. J. H. KESWICK WOULD
BE GRATEFUL FOR ANY
ADVICE OR ASSISTANCE
TOWARDS CLEARING HIS
GARDEN AT 442 HUNGJAO
ROAD OF LAND MINES.

From North-China Daily News,
June 23, 1949. Mr Keswick was the
head of the trading house, Jardines.

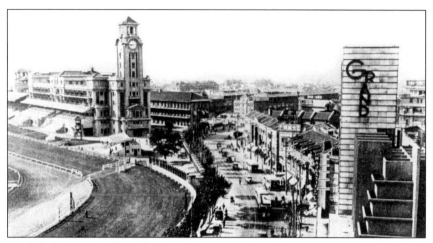

Bubbling Well Rd ...

... was the extension of Nanking Rd heading west. It began at the Tibet Rd intersection, skirted the race course, and headed off towards the airport. It was named after a spring at or near the Jingan Temple.

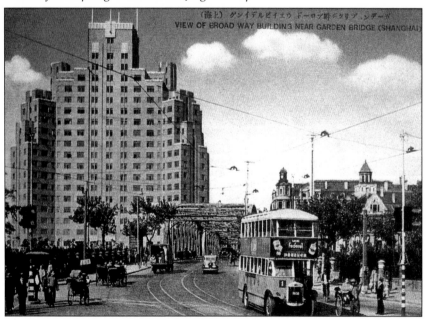

VIEW OF BROAD WAY BUILDING NEAR GARDEN BRIDGE (SHANGHAI)

Business Dealings

An excerpt from The Yangtze Valley and Beyond, *by Isabella Bird*

Of the men I write tremblingly! Chinese tailors seem as successful as Chinese dressmakers, and the laundrymen equal both, no small matter when white linen suits are in question. May it be permitted to a traveller to remark that if men were to give to the learning of Chinese and of Chinese requirements and methods of business a little of the time which is lavished on sport and other amusements, there might possibly be less occasion for the complaint that large fortunes are no longer to be made in Chinese business.

For indeed, from ignorance of the language and reliance on that limited and abominable vocabulary known as "Pidgun," the British merchant must be more absolutely dependent on his Chinese compradore than he would care to be at home on his confidential clerk. Even in such lordly institutions as the British Banks on the bund it seems impossible to transact even such a simple affair as *cashing* a cheque without calling in the aid of a sleek, supercilious-looking, richly-dressed Chinese, a *shroff* or *compradore*, who looks as if he knew the business of the bank and were capable of running it. It is different at the Yokohama Specie Bank, which has found a footing in Shanghai, in which the alert Japanese clerks manage their own affairs and speak Chinese. May I be forgiven?

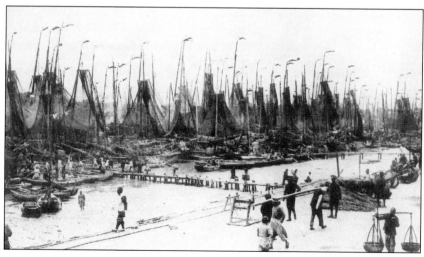

Wusong Port at the beginning of the 20th century

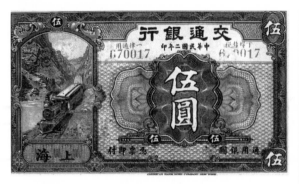

The streets of downtown Shanghai likewise seemed a continuos freak circus at first, unbelievably alive with all manner of people performing almost every physical and social function in public: yelling, gesturing, always acting ...

Edgar Snow

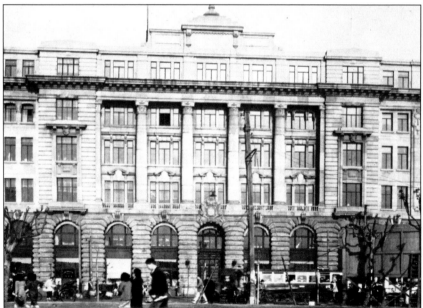

Shanghai office of Jardine, Matheson & Co. on the Bund, 1922.

Shanghai Money

From the book Chinese Imperial Maritime Customs *by Hosea Ballou Morse*

In China, every one of the hundreds of commercial centres not only has its own [silver] tael-weight, but in many cases has several standards side by side; and these taels of money will be weighed out in silver which, even in one place, will be of several degrees of fineness.

The weight of the Shanghai tael is made up of three elements — the weight, the quantity of silver, and a convention. The weight on the scale is the Tsaoping tael of 565.65 grains, the silver is reduced to a standard of 944 fine on the Kuping basis of 1,000 fine, and the convention is that 98 taels of this weight and this silver settle a liability of 100 taels 'Shanghai convention currency'. All official payments at Shanghai are made in this local currency; and the rate of exchange between the Government Treasury, or Kuping, tael is thus calculated:

Kuping taels 100 weight = Tsaoping taels	101.800
Add for touch of pure silver on two shoes	5.600

	107.400
Divide by the 'convention' 0.98	109.592
Add for meltage fee	0.008

	109.600

There results, in consequence, the fixed rate: Tls. 100 Kuping are equivalent to Tls. 109.600 Shanghai, and in the same way, for Customs duties, merchants pay Shanghai Tls. 11.40 as the equivalent of Hai-kwan or Customs Tis. 100.

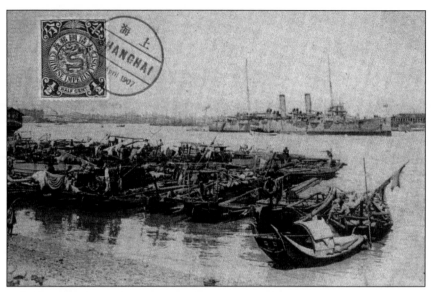

A foreign warship and sampans on the Huangpu River in 1930

Chits

Elsie McCormick in her 1928 book Audacious Angles on China

A person may enter practically any restaurant or cafe and merely inscribe his name and address on a piece of paper at the end of the festivities. The boy who receives the chit has no means of checking up the statistics on it, nor does he ever attempt to do so. He simply files away the memorandum and trusts to the various joss that the signer of it will not feel urged to board any of the numerous trains or boats leaving the city before the first of the month.

The Kennel

China Journal *April 1932*

More Dog-poisoning Cases In Shanghai: Dog owners in the Western District of the Shanghai International Settlement have been warned by the Municipal police to look out for their dogs. On March 23 and 24 no fewer than four valuable dogs were poisoned by some person or persons unknown operating in the Edinburgh and Great Western Roads area. Of the four dogs poisoned two were Great Danes, one was an Alsatian and one a setter. All have died but one of the Great Danes. This is the second time within a year that this kind of thing has taken place. So far no clue to the identity of the perpetrator of these mean and cruel crimes has been discovered. We suggest that all dog owners keep a sharp look out for any suspicious persons loafing in the neighbourhood of their gardens or houses in order, if possible, to detect the culprits.

The Dog Show This Year: While we have heard nothing definite so far on the subject, we presume that the annual Dog Show in Shanghai will take place this year as usual. We see no reason why it should not, although, of course, with what took place in Hongkew and Chapei, when so many people evacuated their homes, there may be a falling off in the number of entries, especially of Chinese owned dogs. Nevertheless we feel that in the interests of all concerned an effort should be made to put on a successful show. Shanghai does not as a rule take water.

United Press dispatch on December 8, 1941
JAPANESE OVERTOOK SHANGHAI INCIDENTLESSLY 080100 UP-CLOSING BANKS BUSINESS INSTITUTIONS WHICH REOPENED LATER UNDER RESTRICTIONS STOP

So Much Life

An excerpt from Aldous Huxley's diary, 1926

I have seen places that were, no doubt, as busy and as thickly populous as the Chinese city in Shanghai, but none that so overwhelmingly impressed me with its business and populousness. In no city, West or East, have I ever had such an impression of dense, rank richly clotted life. Old Shanghai is Bergson's elan vital in the raw, so to speak, and with the lid off. It is Life itself. Each individual Chinaman has more vitality, you feel, than each individual Indian or European, and the social organism composed of these individuals is therefore more intensely alive than the social organism in India or the West. Or perhaps it is the vitality of the social organism – a vitality accumulated and economised through centuries by ancient habit and tradition. So much life, so carefully canalised, so rapidly and strongly flowing – the spectacle of it inspires something like terror. All this was going on when we were cannibalistic savages. It will still be going on, a little modified, perhaps by Western science, but not much-long after we in Europe have simply died of fatigue. A thousand years from now the seal cutters will still be engraving their seals, the ivory workers still sawing and polishing, the tailors will be singing the merits of their cut and cloth, even as they do to-day, the spectacled astrologers will still be conjuring silver out of the pockets of bumpkins and amorous courtesans, there will be a bird market, and eating houses perfumed with delicious cooking, and chemists shops with bottles full of dried lizards, tigers' whiskers, rhinoceros horns and pickled salamanders, there will be patient jewellers and embroiderers of faultless taste, shops full of marvellous crockery, and furriers who can make elaborate patterns and pictures out of variously coloured fox-skins, and the great black ideographs will still be as perfectly written as they are to-day, or were a thousand years ago, will be thrown on to the red paper with the same apparent recklessness, the same real and assured skill, by a long fine hand as deeply learned in the hieratic gestures of its art as the hand of the man who is writing now. Yes, it will all be there, just as intensely and tenaciously alive as ever – all there a thousand years hence, five thousand, ten. You have only to stroll through old Shanghai to be certain of it. London and Paris offer no such certainty. And even India seems by comparison provisional and precarious.

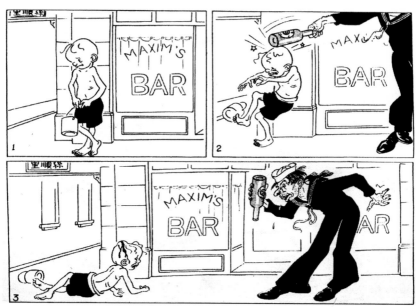

*Chinese cartoonist Zhang Leping created the character Sanmao – a young
vagabond on the streets of Shanghai – who was very popular in the late 1940s.
Evil foreigners were often featured.*

The ricksha pullers paid an outrageously high rental

A Splendid Achievement

From the China Journal, *September 1937, a month after the Japanese attack on Shanghai*

Although all the English daily newspapers in Shanghai have rendered yeoman service during the present crisis by appearing regularly, even though considerably reduced from their usual bulk, and so keeping the English speaking community well informed on current events, we would like specially to congratulate the Shanghai Evening Post and Mercury, Shanghai's American newspaper, on actually increasing its service to the public by running three editions daily, and, for the first time in its history, putting out a Sunday edition, following its motto of "presenting news while it is news." Not only has it done this, it has also extended its broadcasting service, at one period actually giving out hourly broadcasts in cooperation with Station XMHA, situated on Race Course Road. In this connection we would also like to congratulate this Broadcasting Station, as well as Station XQHB, run by Mrs. Robertson at 274 Rue Maresca, on the valuable service they have rendered the community by broadcasting free of charge personal and business messages at a time when it has been practically impossible for people to get in touch with their friends, relatives or business associates through any of the usual channels. Daily these messages have been sent out, and it must have proved of the greatest comfort and help to many to receive them during this time of unprecedented trouble.

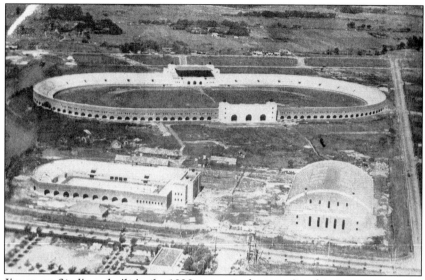

Jiangwan Stadium, built in the 1930s as part of a new city plan

Shanghai Street Jugglers

Shanghai street jugglers around 1900.

Gone Mad

Conman and spy Hilaire du Berrier in a letter to his sister in 1938:

It's hot, I'm tired. Shanghai is full of jews, japs, and gunmen, and it's about a toss-up which are worse. Law and order have gone with the winds and gambling joints and opium dives have taken their place. Shanghai has gone mad; everybody hippity hoppin riotously down the primrose path and running debts to the skies, because tomorrow the whole works may go up in smoke taking banks, book-keeping systems and over-drafts with it.

111

A Day at the Shanghai Races

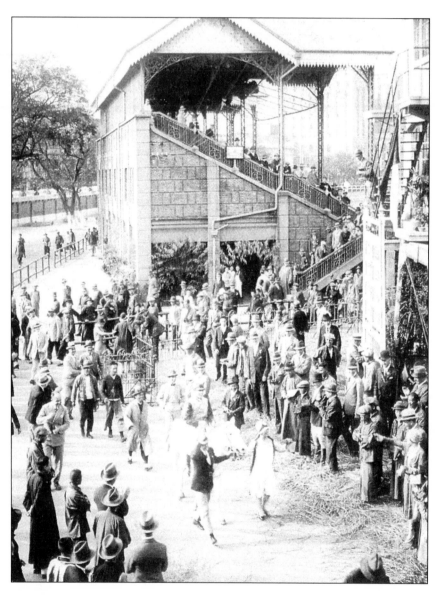

Rickshaws

The rickshaw, a Japanese invention, came to Shanghai in 1874, and became indelibly linked with the image of old Shanghai. It was for many thousands of rickshaw coolies an opportunity to make a subsistence living and was a mode of transport that suited the crowded streets of the city perfectly.

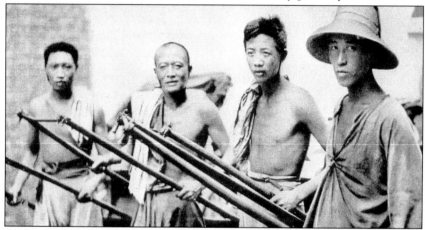

Rickshaw pullers – many were migrants from northern Jiangsu province.

A Boom in Sandbags

From the China Journal, *September 1937, just after the Japanese attack*

Importers fortunate enough to have on hand big supplies of gunny sacks are amongst the few who have done a roaring business in Shanghai during the past five weeks. There has been a hitherto unprecedented demand for these lowly articles of trade in this city since hostilities started with their accompaniment of misdirected bombs and shells and flying fragments of shrapnel. Not only have they been needed as sandbags in constructing defensive works on the boundaries of the International Settlement and French Concession, but business men in all parts of the city, desiring to carry on business as usual, have purchased large quantities to block up the lower windows and protect the entrances of their offices and buildings with sandbags. Shanghai at the moment presents a truly remarkable spectacle, suggesting a beleaguered city, which, in effect, it is.

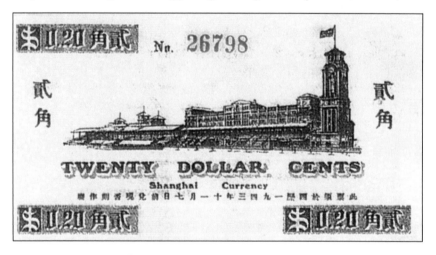

No Imperial City

Lynn Pan in her book Shanghai Style

As the British envisaged their settlement as a trading post, not a colony, they did not lay it out in the grand manner, with authority. There was no civic or architectural display of colonial power, no great boulevard terminating in a triumphal arch or domed structure. Shanghai was no imperial city, but an urban creation of international capitalism.

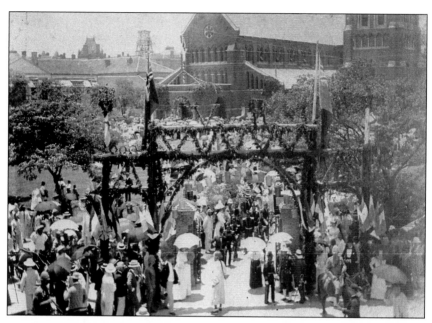

The celebration in 1893 commemorating the 50th anniversary of the founding of foreigner's Shanghai, in front of the Holy Trinity Cathedral.

A Watch Dropped in the Desert

English writers W H. Auden and Christopher Isherwood, describing the state of the Shanghai foreign enclave in May 1939:

An island, an oasis in the midst of the stark, frightful wilderness which was once the Chinese city. Your car crosses the Soochow Creek: on one side are streets and houses, swarming with life; on the other is a cratered and barren moon-landscape, intersected by empty; clean-swept roads ... formidable, excluded watchdogs, the real masters of Shanghai inhabit the dark, deserted Japanese Concession, or roam the lunar wilderness of Chapei, looking down hungrily upon the lighted, populous, international town ... In this city — conquered, yet unoccupied by its conquerors — the mechanism of the old life is still ticking, but seems doomed to stop, like a watch dropped in the desert.

A cartoon by Zhang Leping. Late 1940s Shanghai. Note the orphan boy Sanmao in the middle of the scene.

Japan's Occupation of Shanghai

August 1937 – Chinese areas, Hongkew
Dec 8, 1941 – Foreign Settlements
August 1945 – Surrender

Japanese troops at the Yangshupu Police Station.

British commander-in-chief in India, General Wavell in a telegram to the War Office in London in May 1942, five months after the Japanese occupation of the Shanghai foreign settlement:

Reports from Shanghai indicate British subjects, many of military age, living more or less normal lives, although good prospects of escape exist if effort made. Reports also indicate some continue serve in Police and Municipal Administration. Fact that extremely few British civilians have so far escaped significant in view of these reports. Our prestige will be still further lowered in British subjects continue serve puppet Muncipal Council and if British firms continue to operate by agreement with Japanese as appears to be the case.

People see off a platoon of US Marines on the Bund in November 1941.

Conman and spy Hilaire du Berrier in a letter to his sister in 1938:

Husbands are running wild these days since their families left Shanghai. You know Shanghai's Russian girls are famous the world over. For years they have huddled dejectedly in Shanghai night clubs all the way from Blood Alley to Hungjau, fighting over any lonely males that come their way like lions over a lost straggler — always hungry, broke, tired, homeless. Now all of them have homes and none of them are hungry. Like Mercury, the messenger of the Gods, I propose to live the rest of my life on blackmail.

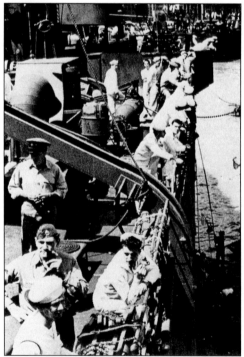

The US Fleet arrives in Shanghai in 1945.

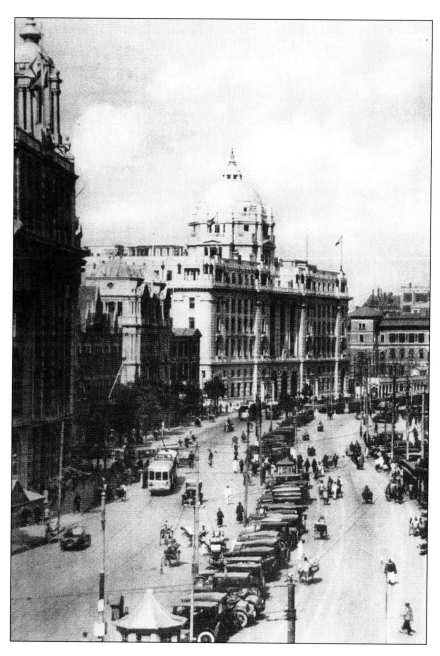

The Hongkong & Shanghai Bank Building

The bank, at 12, The Bund, was the most potent symbol of British financial might in the Far East. The current building opened in 1925. The Bank gave instructions to the architects that no expense was to be spared. It was the first major building in Shanghai to be built on a "raft" which allowed it to float on the mud and silty earth that is the foundation of Shanghai. The bedrock was too far down to be of any use in anchoring the buildings. After the communist victory in 1949, the building served as the headquarters of the Chinese Communist Party and the city government for more than 40 years. The famous pair of lions sitting outside disappeared, but replicas were replaced in 1998.

"The doctrine that China must work out her own salvation has been tried and found wanting. It is not only derided by most intelligent Chinese, but has been abandoned by all thinking foreigners."

HK & Shanghai Bank chairman A.O. Lang at the bank building's opening ceremony in 1925

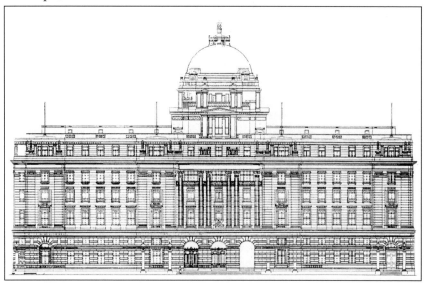

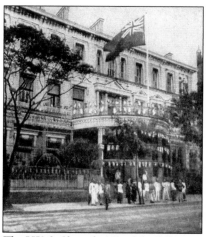

The HK & Shanghai Bank building demolished to make way for the one opened in 1925

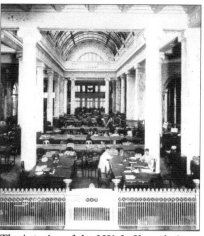

The interior of the HK & Shanghai Bank building. It later became the Shanghai Communist Party HQ

The Shanghai Club

The Shanghai Club, at No. 3, The Bund, was the most exclusive club in Old Shanghai. The January 13, 1911 issue of The North China Daily News reported that on its opening, there was "a guard of honor of armed Sikhs, the Town Band, and later a detachment of bluejackets arrived from the H.M.S. Flora ... and the British Consul General, Sir Pelham Warren, in his brougham escorted by a detachment of Sikh troopers, who presented arms."

The club building is a massive white marble building in the neo-classical style. The main marble-floored hall, over 40 feet high, has six Ionic columns. On the upper floors were a card room, a writing room, dining room, a ballroom, and above that a number of bedrooms for resident members.

All floors were linked by twin elevators which ascended in the middle of the curving marble staircase. No expense was spared in making the club an elegant but comfortable refuge for its privileged members – male only, of course. The North-China Daily News reported it was "lighted with 'Tungstoliers,' a new American method of illumination."

A chit. Better than money

The club was most famous for its Long Bar, reputedly the longest in the world. There, the taipans (big bosses) and griffins (junior officers and clerks) stood in exactly prescribed positions, by rank and as minutely calibrated as on a ruler. Up front near the window would be the leaders of the city's most powerful hongs and down in the shadows on the far end the newest, greenest griffin. God help the new boy in town who did not understand and observe the subtle gradations.

So select was membership that an anecdote is told that, in the days after the Pearl Harbor attack (December 8th in China), a young Briton was passing by the Club just as some incoming rounds were hitting uncomfortably close. For protection he sought to dart into the door of the club only to be stopped short by a Colonel Blimp type who said: "Sir, you cannot come in here, you are not a member." Just then a round landed even closer. The club members consulted and decided to convene a quorum and voted in their unfortunate compatriot – but only as a temporary member.

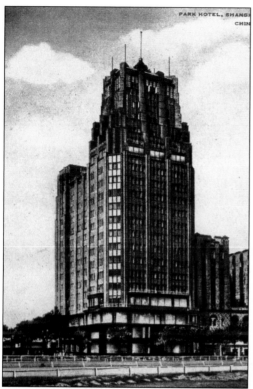

The Park Hotel

For many years the tallest building in Asia, the Park Hotel, with the foreign YMCA next to it, sat opposite the race course on Bubbling Well Rd, and was the most luxuorious hostelry in town. In the late 1930s and early 1940s, it was famous as a hangout for Nazis and many of the other colourful people who populated Shanghai's demi-monde in the run-up to the Japanese ocupation of the Settlements in late 1941, which effectively marked the end of the Glory Days of Old Shanghai.

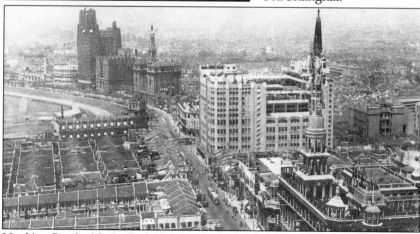

Nanking Road with the Park Hotel at the back left. Photo 1940s.

123

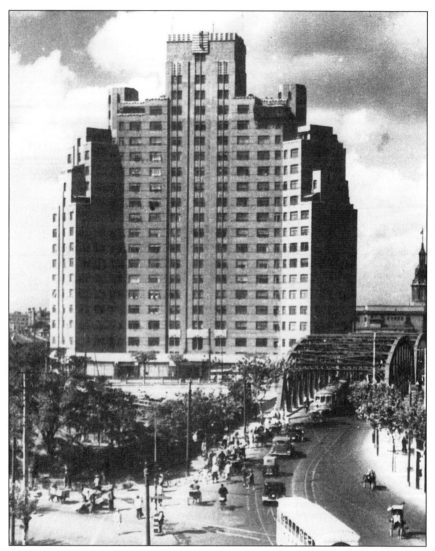

Broadway Mansions

Broadway Mansions, just over the Garden Bridge at the end of the Bund, was built in the mid-1930s, and was taken over by the Japanese military who used it as their headquarters 1941-45.

124

Shanghai's New Civic Centre

China Journal, *May 1935*

Mayor Wu Te-chen of Greater Shanghai and his Associates are to be congratulated on their Vision in laying down plans for a magnificent Civic Centre at Kiangwan, a few miles to the North of the International Settlement, which is destinated to become the Administrative and Cultural Centre of this great City, as well as an attractive residential area. Below is seen a General Plan of the Area at Kiangwan as laid out by the Architect, Mr Da-yu Doon, and accepted by the Council of Greater Shanghai.

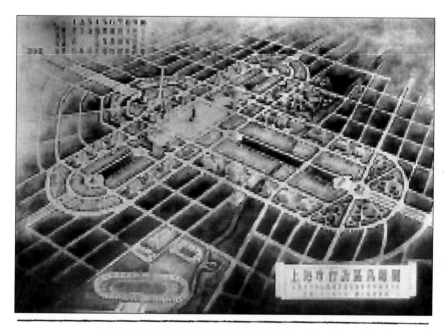

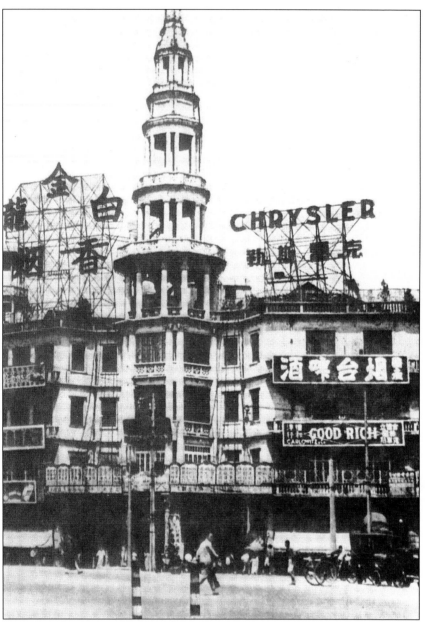

The Great World Amusement Centre on the corner of Yan'an Rd and Tibet Rd

The Great World Amusement Centre

A description of the Great World Amusement Center from film director Joseph von Sternberg in his book Fun In A Chinese Laundry. *Von Sternberg directed the 1934 hit movie* Shanghai Express, *starring Marlene Dietrich.*

"THE ESTABLISHMENT had six floors to provide distraction for the milling crowd, six floors that seethed with life and all the commotion and noise that go with it studded with every variety of entertainment Chinese ingenuity had contrived. On the first floor were gambling tables, sing-song girls, magicians, pick-pockets, slot machines, fireworks, bird cages, fans, stick incense, acrobats and ginger. One flight up were the restaurants, a dozen different groups of actors, crickets in cages, pimps, mid-wives, barbers and earwax extractors. The third floor had jugglers, herb medicines, ice cream parlours, photographers, a new bevy of girls their high-collared gowns slit to reveal their hips, in case one had passed up the more modest ones below who merely flashed their thighs.

"The fourth floor was crowded with shooting galleries, fantan tables, massage benches ... the fifth floor featured girls whose dresses were slit to the armpits, a stuffed whale, story tellers, balloons, peep shows, a mirror maze, two love-letter booths with scribes who guaranteed results, 'rubber goods' and a temple filled with ferocious gods and joss sticks. On the top floor and roof of that house of multiple joys a jumble of tight-rope walkers slithered back and forth, and there were seesaws, lottery tickets, and marriage brokers.

"And as I tried to find my way down again an open space was pointed out to me where hundreds of Chinese, so I was told, after spending their last coppers, had speeded the return to the street below by jumping from the roof ... "

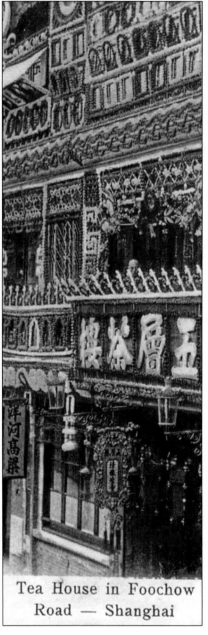

Tea House in Foochow
Road — Shanghai

Street Names

The naming of streets in Old Shanghai differed according to area. The French gave French names to virtually all the roads in their Concession. The British likewise, except for the central area of the city where the streets were given the names of Chinese cities and provinces. The foreign names have all been scrapped but the Chinese placename streets have been retained. So Nanking Rd of old is now Nanjing Lu, Foochow Rd became Fuzhou Lu, Szechuan Rd became Sichuan Lu etc. Changes of transliteration only. (The city named streets go east-to-west and the provinces north-south). The name of the Bund, the premier street in the city, is originally an Anglo-Indian word, a reflection of Shanghai's position in the global British Imperial network.

The French named their thoroughfares mostly after French dignitaries. Some like Boulevard de Montigny, were named after French consuls and ambassadors to China (de Montigny was the founder of the French Concession and the first French consul in Shanghai). Some were named after prominent French citizens in Shanghai, such as Pichon, Chapsal or the wine merchant Remi, or after priests who worked in the large Catholic cathedral in Xujiahui at the southwest edge of the French Concession. Others were named after famous people back in France, including Joffre, Corneille and Moliere.

Now	Then	Now	Then
Beijing Lu	Peking Road	Jiangsu Lu	Edinburgh Road
Beijing Xi Lu	Avenue Road	Jiangxi Lu	Kiangse Road
Changde Lu	Hart Road	Jinling Dong Lu	Rue du Consulat
Changle Lu	Rue Bourgeat	Jinling Xi Lu	Avenue Foch (East)
Changshu Lu	Rte. de Sayzoong	Jinshan Lu	Astor Road
Changming Lu	Brenan Road	Jiujiang Lu	Kiukiang Road
Changyang Lu	Ward Road	Liyang Lu	Dixwell Road
Changzi Dong Lu	Seward Road	Maoming Bei Lu	Moulmein Road
Dalian Lu	Dalny Road	Maoming Nan Lu	Moulmein Road
Daming Lu	Broadway	Nanjing Xi Lu	Bubbling Well Road
Danshui Lu	Rue Chapsal	Panyu Lu	Columbia Road
Dinghai Lu	Point Road	Renmin Lu	Blvd Deux Republics
Dongdaming Lu	Seward Road	Ruijin Er Lu	Route Pere Robert
Dongdaming Lu	Broadway East	Shaanxi Bei Lu	Seymour Road
Donghu Lu	Route Doumer	Shimen Er Lu	Carter Road
Fengyang Lu	Burkhill Road	Sichuan Nan Lu	Rue Montauban
Fenyang Lu	Rte. Pichon	Tianmu Dong Lu	Boundary Road
Fumin Lu	Route Amiral Coubert	Tongren Lu	Hardoon Road
Fuxing Xi Lu	Route G. de Boissezon	Wulumuqi Bei Lu	Route Magy
Fuxing Zhong Lu	Rue Lafayette	Wulumuqi Nan Lu	Route Louis Dufour
Fuzhou Lu	Foochow Road	Wanhangdu Lu	Jessfield Road
Gaoan Lu	Route Cohen	Wujiang Lu	Love Lane
Gaolan Lu	Rue Corneille	Wujin Lu	Range Road
Guangdong Lu	Canton Road	Wukang Lu	Route Ferguson
Hami Lu	Rubicon Road	Xiangshan Lu	Rue Moliere
Hengshan Lu	Avenue Petain	Xiangyang Nan Lu	Rue de la Tour
Huoshan Lu	Wayside Road	Xingang Lu	Rue Marcel Tillot
Huaihai Lu	Avenue Joffre	Xinle Lu	Rue Paul Henry
Huashan Lu	Avenue Haig	Xuchang Lu	Washing Road
Huangpi Bei Lu	Mohawk Road	Yanan Dong Lu	Avenue Edward VII
Huiming Lu	Baikal Road	Yanan Xi Lu	Great Western Road
Huqiu Lu	Museum Road	Yanan Zhong Lu	Avenue Foch (West)
Jianguo Dong Lu	Route Conty	Yongkang Lu	Rue Remi
Jianguo Lu	Rue Chevalier	Yueyang Lu	Route Ghisi
Jianguo Xi Lu	Route J. Frelupt	Zhoushan Lu	Chusan Road

129

Original Owners and Occupants of Buildings Along The Bund

The buildings along the Bund and what they were, starting from Yanan Lu to the south and working north.

No. 1 Opened in 1915 as the McBain Building, also called the Asiatic Petroleum Building and later the Shell Building.

No. 3 (now No. 2) The Shanghai Club, opened in 1911, replacing an earlier club building from 1864. It boasted the longest bar in the world. Part of the bar, which was originally nearly 111 feet long, was still to be found upstairs when the building closed in 2000.

No. 4 (now No. 3) The Union Assurance Company of Canton Building opened in 1915, with part of it being taken over by the Mercantile Bank of India, Ltd. in 1935. It was resurrected as Three on the Bund in 2004.

No. 5 The Nisshin Kisen Kaisha (NKK) Building, completed in 1921 for a Japanese shipping line that plied the Chinese coast and the Yangtze River.

No. 6 One of the oldest buildings on The Bund, erected for the great American trading firm of Russell & Co. in 1881. It was taken over by the Imperial Bank of China in 1897 and was home to the P&O Banking Corporation in the 1920s and 30s. Opened as 6 Bund in 2006.

No. 7 The Great Northern Telegraph Building, completed in 1908, provided premises for three telegraph companies before being taken over by the Commercial Bank of China in 1922.

No. 9 Completed in 1901 for the China Merchant Steamship Navigation Co. The company had kept offices in the 1855 Stone House building to its rear since 1885.

No. 12 The Hongkong and Shanghai Bank was the finest bank building in the Far East when it opened in 1923. Its spectacular interior, featuring Venetian mosaics panels and Sienna marble has been carefully restored.

No. 13 The Custom House, completed in 1927. The entrance hall features fine mosaics of Chinese junks. Like its former English Tudor-style building that stood on the site from 1894, its clock, known as "Big Ching," played the chimes of London's Big Ben.

No. 14 The last building to be erected on the Bund was completed in 1948 for the Bank of Communications. They had previously occupied the old building of the German-Asiatic Bank on the site since 1920.

No. 15 Palatial and modern premises opened in 1902 to house the Russo-Chinese Bank. Taken over by the Central Bank of China in 1928.

No. 16 Housed the Bank of Taiwan (Japanese) and the offices of architects Lester, Johnson and Morriss, who designed the building. Opened in 1927.

No. 17 Completed in 1924 and home of the North-China Daily News, "the Grand Old Lady of the Bund." The

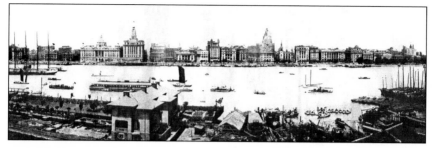

American Asiatic Underwriters, the founding company of today's AIG, leased a large part of the building in 1927. They took a modern-day lease on the building in 1998.

No. 18 The premises that were built for the Chartered Bank of India, Australia and China in 1923 are now home to the galleries and restaurants of Bund 18. Awarded a UNESCO heritage award in 2006 for its fine restoration.

No. 19 The Palace Hotel, built between 1904 and 1909, was taken over by the Hongkong and Shanghai Hotels in 1923, and was the south wing of the Peace Hotel before its closure in 2007.

No. 20 Opened in 1929 as Sassoon House incorporating the Cathay Hotel – combining business premises and a state-of-the-art luxury hotel. Its legendary owner, Sir Victor Sassoon, kept a penthouse suite at the base of its pyramidal copper tower.

No. 22 The Bank of China originally occupied the Gothic-style premises of the former German Club, the Club Concordia, in 1920. That building was demolished to make way for its towering new Art Deco edifice that the Bank occupied after the Second World War.

No. 24 Neo-classical style building with Japanese adornments completed in 1924 for the Yokohama Specie Bank,

Japan's largest financial institution in China. Two disfigured Japanese warrior heads, carved in stone, have survived above the ground floor windows.

No. 26 The Yangtsze Insurance Building, which was completed in 1918, originally also housed the offices of the Mercantile Bank of India. It later housed the Italian Chamber of Commerce and the Danish Consulate.

No. 27 Jardine, Matheson & Co., one of the great trading firms of the China Coast, registered the first lot on the Bund here in 1843. The second, and surviving, EWO Building (EWO being the Chinese name of the company) was completed in 1922.

No. 28 The fine Glen Line Building, home to a shipping line with a Scottish pedigree, was completed in 1922. The German Consulate moved in 1937 and after the war it was occupied by the American Navy and latterly by the American Consulate.

No. 29 The building for the Banque de l'Indo-Chine, designed by Atkinson & Dallas, was opened in 1914.

No. 32 The British Consulate building, completed in 1873, is the oldest surviving structure on The Bund.

No. 33 The British Consular Residence, dating from 1883.

Neutral Grounds

From The Diamond Jubilee of the International Settlement of Shanghai, 1938

On the fertile plains of a province so aptly called the Garden of China, there grew a fair city. Eventful was its life, and colourful its history. Through the ages it grew in size and importance until today it stands, an island of peace, undisturbed, whether calm or turbulent waters surround it... (It is) now as ever, a stronghold of justice and friendliness, a welcome citadel to one and all who might seek refuge on its neutral grounds.

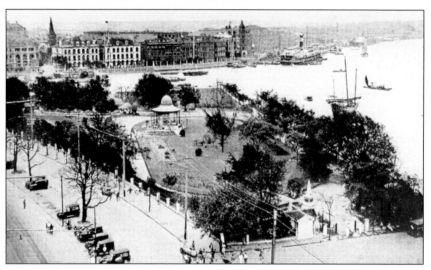

The Public Gardens, on the Bund, at the confluence of Suzhou Creek and the Huangpu River, taken early 20th century. Note the bandstand.

Education

Dr Wellington Koo, Chinese Minister to the United States during the First World War and senior member of the Chinese delegation to the Paris Peace Conference in 1919, was guest of honour at a dinner in London and his neighbour – not realising who he was – asked condescendingly: "Likee soupee?" Dr Koo smiled and said nothing. At the end of the dinner he gave a brilliant speech in faultless English, then returned to his seat and said to his neighbour: "Likee speechee?"

132

> The Chinese are perhaps the most practical people on earth, and a curious system of moral bookkeeping adopted by many shows this feature of the national character in every curious light.
>
> *Isabella Bird,* The Yangtze Valley and Beyond, *1899*

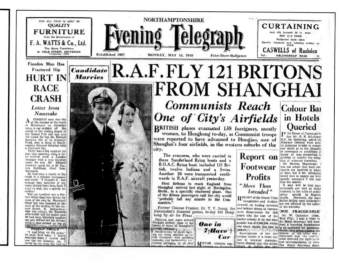

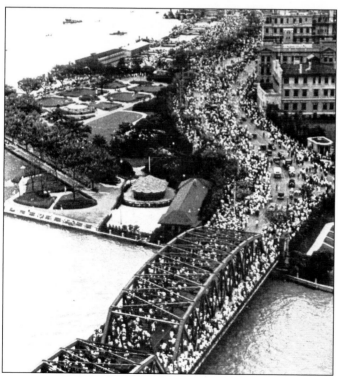

When Shanghai was bombed by the Japanese in 1937, refugees streamed across the Garden Bridge from Hongkou to the supposedly safer districts of the International Settlement.

Justice and Harmony

Memorandum on Naming of the Shanghae Streets, by Consul Walter Henry Medhurst, British Consulate, May 5, 1862

The foreigners being the dominant portion of the community and charged with the order and security of the Settlement, while the Chinese are but recent immigrants, who have swarmed in for their own conveniences and safety, it follows, that, if either has the right to enforce on the other a system of nomenclature as near as possible adapted to the necessities of both, the foreigners possess that right: and it is one which must be exercised, or the Chinese part of the population, with their usual sagacity for mutual combination, will ever long make the entire settlement a Chinese city, and we shall find such names as, if translated would read, "Virtue and Benevolence Street," "Painted Silk Lane," "Justice and Harmony Road" intruding themselves in flaming characters alongside the less modest appellations the Municipal Council has already posted up. This is no imagination, but a most probable contingency, as any one may judge of, who will take the trouble to walk the back streets, and read for himself, presuming him to be acquainted with the Chinese character.

Granting then that the foreign portion of the community is entitled to decide on the system of nomenclature best adapted to both, it is I think due to the Chinese and a matter of public utility, that such terms as they are more familiar with, and can pronounce, should be adopted if possible, and this may be done by taking the names of their own Provinces, Cities and Rivers, which are equally well known to ourselves, and this is the scheme I have to recommend to the acceptance of the Municipal Council.

Reprinted from Peter Hibbard's The Bund
Shanghai, 2007

中法聯誼會會所成立團會紀念 22.5.34.

The Sino-France Union hosting an anniversary ceremony.

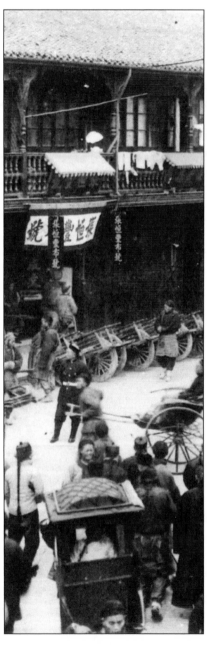

Park Regulations, 1917

**PUBLIC AND RESERVE
GARDENS.
REGULATIONS.**

1. The Gardens are reserved for the Foreign Community.
2. The Gardens are opened daily to the public from 6 a.m. and will be closed half an hour after midnight.
3. No persons are admitted unless respectably dressed.
4. Dogs and bicycles are not admitted.
5. Perambulators must be confined to the paths.
6. Birdnesting, plucking flowers, climbing trees or damaging the trees, shrubs, or grass is strictly prohibited; visitors and others in charge of children are requested to aid in preventing such mischief.
7. No person is allowed within the band stand enclosure.
8. Amahs in charge of children are not permitted to occupy the seats and chairs during band performances.
9. Children unaccompanied by foreigners are not allowed in Reserve Garden.
10. The police have instructions to enforce these regulations.

By Order.
N. O. Liddell.
Secretary.
Council Room. Shanghai.
September 13th. 1917

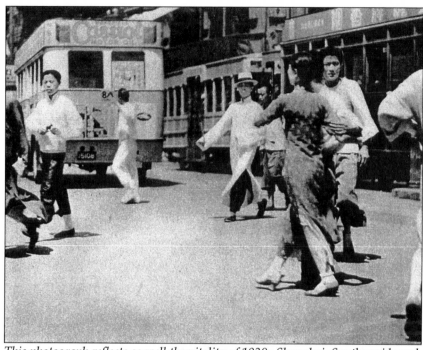

This photograph reflects so well the vitality of 1930s Shanghai. See the pride and confidence of the Shanghainese stride, and their Chinese dress too.

Pidgin Phrases for Tourists

From The Cathay (Hotel) magazine, 1932

I want some tea at once	Catchee tea chop chop
Get me some hot water	Pay my hot water
I want a bath	My wanchee bath
How much is that?	How muchee?
I don't like that	No likee
Is that the lowest price?	No can cuttee?
Is the bargain settled?	Can puttee book?
Do you mean it?	Talkee true?
What do you mean by that?	What fashion?
Can you send this to the Cathay?	Cathay Hotel side can sendee?

Safety Always

From The Motorists' Guide and Road Maps for Shanghai & District, *The Automobile Club of China 1932*

Advice for Drivers on the Shanghai Roads: Paradoxically, a stray hen on the road is best avoided by running into it, you will never hit it. This hint is for emergency use; normally. You should be able to slow up sufficiently.

Use your hooter with discretion; a wavering pedestrian who could be passed safely without its use may become panic stricken if you hoot at him repeatedly.

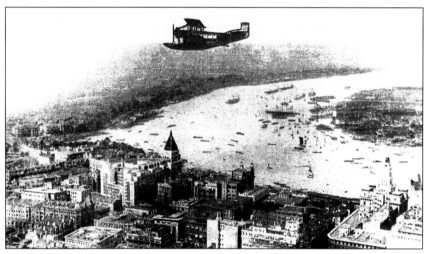

A Pan-Am Clipper flying over Shanghai in maybe 1947

Total Eclipse of Moon Seen in Shanghai

From China Journal, *February 1936*

Perfect weather conditions prevailed in the Shanghai area on the night of January 8, enabling residents to enjoy a good view of the total eclipse of the Moon… For some reason there was not nearly as much hubbub on the part of the Chinese as usual, although there was a certain amount of cracker firing and beating of gongs and tin cans. This is done by the superstitious to prevent the heavenly dog from swallowing the Moon.

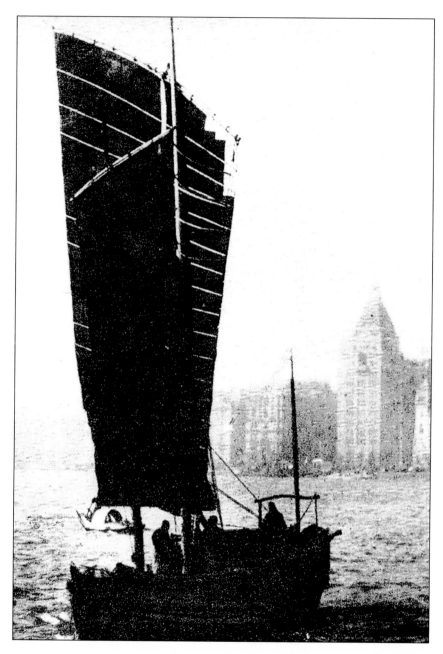

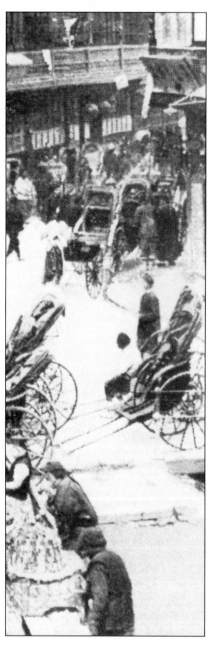

The Shanghai Look

From The Town Traveler, May 1926

Casting about for material evidence of Shanghai's greatness, the casual observer might be content to rest his boast of this on such commonplaces as cosmopolitanism, trade, traffic and number of inhabitants, to say nothing of the up-to-date mechanical facilities the city possesses, overlooking the fact that it is none of these that places a city, directly, in the rank of a metropolis.

It is to be remarked that no aggregation of bricks and mortar populated by humans, can justly claim to be a World City until the inhabitants have developed some marked physical deformity which is ascribed to the facilities that they enjoy. Thus, we read from time to time that people, elsewhere, have developed the subway strain, the elevator ear, the telephone tongue or the radio rickets. The questing physician, anxious to keep him himself in the spotlight, bombards magazine and newspaper with accounts of some new disease traceable to the mechanical contrivances of the age.

Shanghai, accordingly, has achieved a place in cities of the first rank. We have developed a facial contortion all our own. This is the Shanghai Look or better, Glare, and is, of course, caused by the congested condition of our streets.

The casual tourist, that is to say, the one whose ship stops here only long enough to enable him to pass an hour or two with us, is apt to leave with the impression that undying hatred exists between the inhabitants of the Paris of the East. Indeed, if looks could kill, there would be very few of us left to care whether Shanghai were known as the Paris of the East or the Plaster of Paris of the East.

To begin with, there is the pedestrian, whose peace of mind and dignity are constantly assailed by the behaviour of the ricsha, the bicycle, the motor-cycle, the motor-car, the omnibus, the trams (railless and regular) the broker's carriage, the handcart, the wheelbarrow and the carry-pole. For each of these, he has developed an intense animosity that is clearly reflected in his countenance. Then there is the withering glance exchanged between the occupant of a private ricsha and the passenger in a public one, when the coolie of the latter attempts to get ahead of the coolie of the former. The two, however, soon forget this grievance in a combined scowl at a bicyclist or motor-cyclist or someone else.

Next come the people who are trying either to board or to descend from a tramcar. Every authorized stopping place for these conveyances is obscured by an inky aura, begotten of black looks that might lead even an experienced naturalist to conclude that there had been a cuttle-fish about.

And so it goes. To reach an estimate of the total number of glares, you have only to take the conveyances which infest our streets and combine and permute them with one another and with the pedestrian, in approved mathematical sequence. A smile is so rarely seen in public, nowadays, as to bring its betrayer under immediate suspicion that he is mentally unsound and should not be permitted at large.

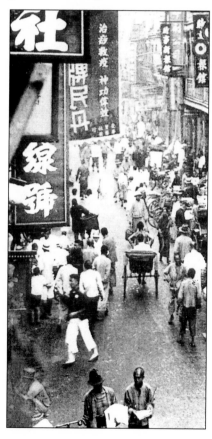

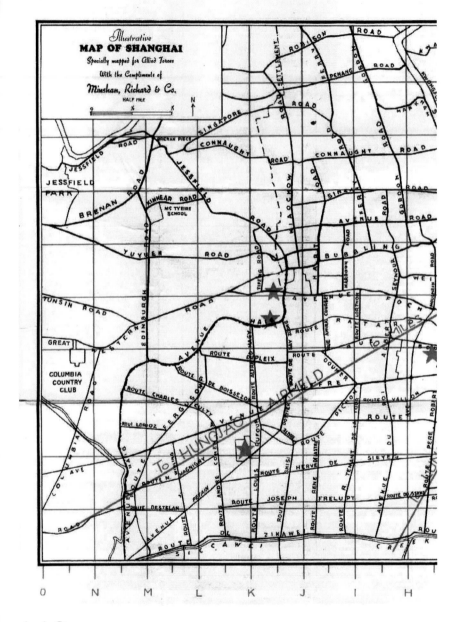

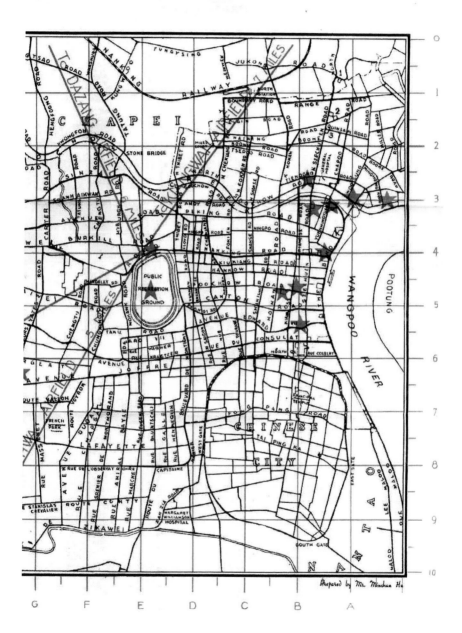

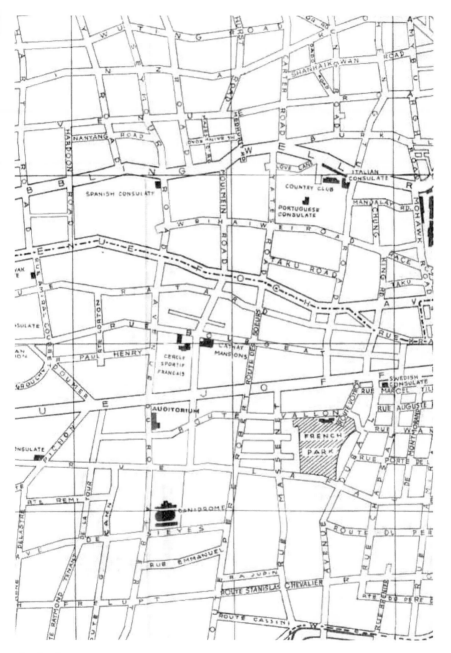

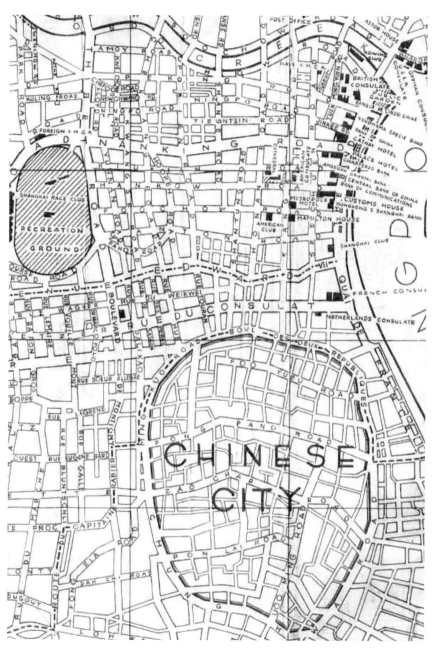

Bibliography

Essential Old Shanghai Reading

All About Shanghai, A Standard Guidebook (1934-5). Reissued in Oxford Paperbacks, Hong Kong, 1986.*

Baker, Barbara. Shanghai: Electric and Lurid City. Oxford University Press, Hong Kong, 1998.

Ballard J.G.. Empire of the Sun. Buccaneer Books, 1987.

Barber, Noel. The Fall of Shanghai: The Communist Take-Over in 1949. Macmillan, London, 1979.

Baum, Vicky. Shanghai '37 (1939). Reissued in Oxford Paperbacks, Hong Kong, 1986.*

Bickers, Robert. Empire Made Me: An Englishman Adrift in Shanghai. Allen Lane, London, 2003.

Bird, Isabella. The Yangtze Valley and Beyond (1899). Reprinted by China Economic Review, Shanghai, 2008.

Bland, J.O.P. Houseboat Days in China. E. Arnold, London, 1909.

Clifford, Nicholas. Spoilt Children of Empire: Westerners in Shanghai and the Chinese Revolution of the 1920s. Middlebury College Press, 1991.

Crow, Carl. Handbook For China (1933). Reissued in Oxford Paperbacks, Hong Kong, 1986.

Crow, Carl. Foreign Devils in the Flowery Kingdom, (1940). Reprinted by China Economic Review, Shanghai, 2007.

Deke Erh and Johnston, Tess. Shanghai Art Deco. Old China Hand Press, Hong Kong, 2006.

Denison, Edward and Guang Yu Ren. Building Shanghai: The Story of China's Gateway. Wiley Academy, 2006.

Dong, Stella. Shanghai: The Rise and Fall of a Decadent City. Perennial, New York, 2001.

French, Paul. Carl Crow — A Tough Old China Hand. Hong Kong University Press, 2006.

Hawks Pott, F.L. A Short History of Shanghai. Kelly & Walsh, Shanghai, 1928.*

Hibbard, Peter. Beijing and Shanghai: China's Hottest Cities. Odyssey, Hong Kong, 2004.

Hibbard, Peter. The Bund Shanghai: China Faces West. Odyssey, Hong Kong, 2007.

Jackson, Stanley. The Sassoons. Heinemann, London, 1968.

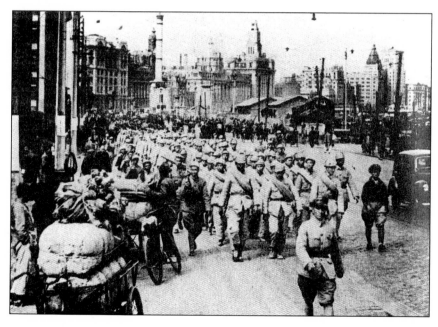

Johnston, Tess and Deke Erh. A Last Look – Revisited – Western Architecture in Old Shanghai ... Old China Hand Press, Hong Kong, 2004.

Johnston, Tess and Deke Erh. Frenchtown Shanghai. Old China Hand Press, Hong Kong, 2000.

Malraux, Andre. Man's Estate, Penguin, 1961.

McCormick, Elsie. Audacious Angles of China. 1924

McCormick, Elsie. The Unexpurgated Diary of a Shanghai Baby. Published in 1924. Republished by Earnshaw Books in 2007.

Oliphant, Lawrence. Narrative of the Earl of Elgin's Missions to China and Japan 1857-59. Harper Brothers. 1860.

Pan, Lynn. In Search of Old Shanghai. Joint Publishing Co., Hong Kong, 1982.

Pan, Lynn. Old Shanghai: Gangsters in Paradise. Heinemann Asia, Hong Kong, 1984.

Pan, Lynn. Shanghai — A Century of Change in Photographs 1843-1949. Hai Feng Publishing, 1993.

Pan, Lynn. Shanghai Style. Long River Press. 2008.

Seagrave, Sterling. The Soong Dynasty. Sidgwick & Jackson, London, 1985.

Sergeant, Harriet. Shanghai. Jonathan Cape, London, 1991.

Shaw, Ralph. Sin City. Time Warner Paperbacks, new edition, 1992.

Spence, Jonathan. God's Chinese Son: The Taiping Heavenly Kingdom of Hong Xiuquan. Norton, 1996.

Wakeman, Frederic Jr. Policing Shanghai 1927 – 1937. University of California Press, 1995.

Warr, Anne. Shanghai Architecture. Watermark Press, 2007.

Wasserstein, Bernard. Secret War in Shanghai. Profile Books, London, 1998.

Wei, Betty Peh-T'i. Shanghai: Crucible of Modern China. Oxford University Press, Hong Kong, 1990.

Wood, Frances. No Dogs and Not Many Chinese. John Murray, London, 1998.